STIRLING in
100 OBJECTS

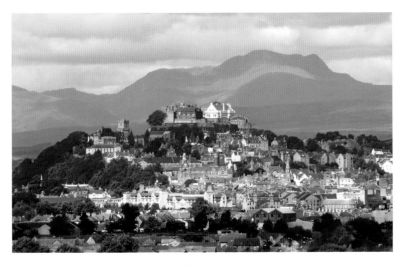

The city of Stirling. (Photograph by John McPake)

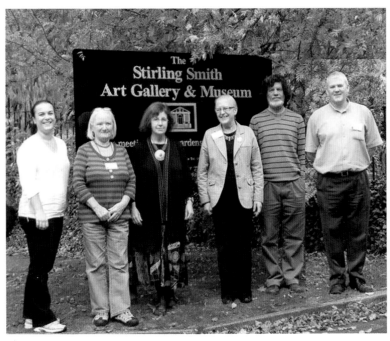

Staff at the Stirling Smith Art Gallery & Museum. From left to right: Silvia Anestikova, Evelyn Cameron, Elspeth King, Margaret Job, Michael McGinnes and Vincent Connell.

a **HISTORY** of **STIRLING** in **100 OBJECTS**

Elspeth King

Elspeth King

16 June 2011

The History Press

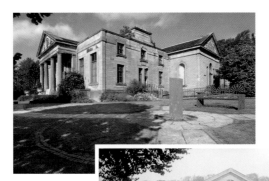

The Stirling Smith in 2010 (above) and in 1910 (right).

First published 2011

The History Press
The Mill, Brimscombe Port
Stroud, Gloucestershire, GL5 2QG
www.thehistorypress.co.uk

British Library Cataloguing in Publication Data.
A catalogue record for this book is available from the British Library.

ISBN 978 0 7524 5932 5

Typesetting and origination by The History Press
Printed in China
Manufacturing managed by Jellyfish Print Solutions Ltd

CONTENTS

ACKNOWLEDGEMENTS

MANY OF THE objects in this book have featured in the weekly Stirling Story column of the *Stirling Observer*, and we are grateful to *Observer* staff for the generous space given to museum matters in the past decade. The suggestion for the book came from David Kinnaird, who has haunted tourists in the last twenty years in the persona of Jock Rankin, the Stirling hangman of the mid-eighteenth century. The text management and some of the photography was undertaken by Silvia Anestikova, Administrator of the Stirling Smith. Most of the photography and all of the digitisation and image management is by Michael McGinnes, Stirling Smith Collections Curator since 1979. The text was proofread and many helpful suggestions made by Margaret Job, Stirling Smith Receptionist since 1983.

We are grateful to Bob Jack, Chief Executive, Stirling Council for allowing the reproduction of the image from the Alexander II window in the Municipal Buildings and to Frank Lennon, Rector of St Modan's High School, for permission to include the school's window of St Andrew. All of the other images are from the Stirling Smith collections.

There are constant references in the text to people who have rescued material for or donated objects to, or have assisted with the conservation or refurbishment of objects for the Stirling Smith. The creation of a museum collection of significance is dependent on the foresight, generosity and community concern of a large number of individuals. They work with museum staff to manufacture the medicine which prevents community and civic amnesia, and guards against the destructive forces of collective dementia. We are grateful to all of them.

Thanks is also due to the staff of the National Fund for Acquisitions, administered with government funds by the National Museum of Scotland and Common Good Fund of the City of Stirling, administered by Stirling Councillors, who have helped purchase objects and paintings which would otherwise have been lost to Stirling.

Elspeth King, 2011

IT GIVES ME great pleasure to introduce this book. It is often said that the history of Stirling is the history of Scotland. With its central location at the crossroads of Scotland's history and geography, and characterised as Scotland's Heart, Stirling has been important from prehistoric times. It features heavily in histories of Scotland, and has been the subject of many local specialist studies.

This history is totally different from all the others, as it is written from the perspective of the objects, most of which are in the collections of the Stirling Smith Art Gallery and Museum, established in 1874. The citizens of Stirling are the proud owners of the fine collections which are kept by the Stirling Smith in trust on their behalf.

The collections have worked to promote good relationships between Stirling and other parts of the world. During my time as Provost of the City of Stirling, I had the pleasure of taking William Wallace's Sword (2005), then the Wallace collection (2006) to New York Tartan Week. In 2006, I also took the world's oldest football to the Hamburg Ethnographic Museum, where it was the centrepiece of an exhibition on the history of football, staged for the World Cup.

As Chairman of the Trustees of the Stirling Smith Art Gallery and Museum, my Trustees and I regularly consider loan requests from other museums, both at home and abroad. In recent years, my Trustees have been pleased to lend objects and paintings to the Tower of London, the Alhambra Palace in Andalusia, Spain, and to the Kunsthal in Rotterdam. Such requests have been received and met from the time of the Glasgow International Exhibition of 1901 onwards.

The BBC and British Museum's 'History of the World in 100 Objects' has been inspirational for all of us. During the broadcast time, hundreds of children have come into the Smith to take up the CBBC *Relic: Guardians of the Museum Challenge*, and discover their own history.

Whilst BBC Scotland selected sixty objects from Scottish museums across the country to feature in its radio programmes, we are delighted to offer 100 objects from the Stirling Smith alone for this history of Stirling. We hope that readers will recognise why the Smith, through its collections, is the Soul of Stirling, Scotland's Heart.

Councillor Colin O'Brien
Chair of the Stirling Smith Art Gallery and Museum Trustees
Provost of Stirling 2003-2007

INTRODUCTION

WRITING THE HISTORY of a town or city through the objects and artefacts, gathered in its museum collections, is a different discipline from writing a history in the traditional sense. Historians from an academic background, trained in archival research and totally document-focussed, are often blind to museum collections. This is particularly the case in Scotland where Lord Hailes (1726-1792) 'the father of national history' founded the discipline on the study of documents as the only reliable source. His intellectual successors today have maintained that tradition by dismissing museums as a decorative social frill, 'A bit like a well-heeled family decorating the living room by putting old snapshots of the family into silver frames.' ('Museumry and the Heritage Industry' by George Rosie in *The Manufacture of Scottish History*, ed. Donnachie and Whatley.) In the past twenty-one years, there has been much deconstruction of 'The Manufacture of Scottish History', criticism of heritage industry presentations and condemnation of the supposed perpetuation of myth and ignorance about Scotland's history.

The audacious *A History of the World in 100 Objects* presented by another Scot, Neil MacGregor of the British Museum, has swept aside all such negative thinking on museums and museum collections. People relate to and talk about the keepsakes of their personal or family history very easily, as the mass uploading of images to the BBC's History of the World website has shown. We all keep tokens from our personal lives – our first shoes, a toy, a concert ticket, a wedding favour, a piece of music. Museums do the same for the lives of the community they represent. In this, there is little duplication of collections, for unlike libraries, there is no statutory requirement for communities to set up and maintain museums or museum collections. Nevertheless, museums are the mark of a civilised society, one which has enough self-respect and resources to collect, curate and represent its shared past for the common good.

It has been difficult to select a token 100 objects from the many thousands in the Smith's collections. With the need to present a historical narrative, many of the objects show how individuals have made sense of the past – for example, how artists in modern times have tried to imagine and depict the Battle of Bannockburn, or how people have learned about it through collecting cigarette cards, in a generation when no Scottish history was taught in schools.

Stirling has had many different identities in the last 800 years, most of which are represented by the objects chosen. These may be summarised as follows:

Royal burgh Stirling is one of the four principal royal burghs in Scotland. All of the charters and privileges were confirmed by Alexander II in 1226 and the burgh seal dates from 1296.

Royal residence Stirling was the favoured residence of the Stuart kings. The courts of James IV and his son James V equalled every other in Renaissance Europe, with scholars such as George Buchanan, musicians like Robert Carver, and playwrights like Sir David Lindsay, whose works and plays are still being read, played and performed after 450 years.

Market town Stirling has always been the market place for Stirlingshire and much of the rest of Scotland where livestock is concerned. Stirling has lived by buying and selling cattle for 300 years, and United Auctions livestock marts built their Scottish headquarters in Stirling in 2009.

Brewing centre Because of its importance in brewing, Stirling was given the right to set the standard for the liquid measure as early as 1457.

County town Stirling was the capital of the county of Stirlingshire. The County Buildings (now the Sheriff Court, Viewfield Place) and the County Club in Murray Place (demolished 1960s) were important institutions. Between 1975 and 1996, Stirling was also the location of the headquarters of Central Regional Council.

Garrison town This was its function after the Stuarts left in 1603.

Historical crossroads The castle and bridge were the defence for what was known as 'Scotland across the sea' in medieval times, and now Stirling welcomes invading tourists too.

Geographical crossroads This is the reason that six battles which changed the course of Scottish history were fought in, or near, Stirling. It is also why Cornton Vale, the principal Scottish women's prison, was established in Stirling in 1975.

Doncaster of Scotland This was the hope of William Ramsay of Barnton MP, who laid out the racecourse, and funded the Stirling Gold Cup. He died in 1850, and racecourse died soon after.

Agricultural supplies On account of the rich carse land, there were major trading firms for this here.

Port Stirling had a port from medieval times. It too was requisitioned by the army. The community of retired sailors and sea captains has left the Smith a collection of rare nautical and navigational instruments to represent their trade.

Textiles and tartan After the 1745 Jacobite Rising, Stirling was the first town outside of the highlands which was allowed to manufacture tartan – and made a world-wide trade from it.

Artists' town Stirling had the only school of animal art in Scotland, with Denovan Adam's Craigmill Studio in the period 1870-90, and was an attraction for many of the so-called 'Glasgow Boys'.

Literary town Robert Burns and Sir Walter Scott both held Stirling in high regard, and led the way for others.

Coach-building town The firm of William Kinross and Co. were coach builders with numerous royal warrants. In business from 1806 until they were supplanted by the Thistle Shopping Centre in the 1960s, they made the state coach of Spain, now in a museum in Madrid.

Evangelical centre The work of the Drummond Tract Depot operated on a global basis, c. 1870-1981.

Printing and publishing With Drummond and Eneas Mackay in the nineteenth and twentieth centuries, Stirling was a force to be reckoned with.

Railway town Right from 1848, the railways were of central importance.

Mining town With the opening of deep mines in the east of Stirling in the early twentieth century, mining was a main industry. The miners were housed in the top of the town, and then re-housed in the Raploch, changing the political and social make-up of Stirling.

Ordnance town The Royal Army Ordnance Depot in Stirling was one of the principal British depots, covering the estate of Forthside and using the exclusive services of the river, with a share in the railway.

University town Stirling was the first new Scottish university to be built (1967) after Edinburgh was founded in the sixteenth century.

Tourist centre As a place of outstanding natural beauty, Stirling has had a thriving tourist trade for over 200 years.

City On 12 March 2002, Stirling obtained City status.

There have been many occasions when people in Stirling have been careless of the past, and this too is reflected in the text. The objects are arranged roughly in chronological order, but often are referenced across several centuries, as the past continues to inform the present.

In Stirling, the Stirling Smith is Stirling's collective memory box, secular cathedral, gathered past and spiritual treasury. The collections are very different from museums in other towns, and so are the stories which they tell. The Stirling Smith is one of 340 local museums in Scotland. If every curator had the means of presenting a history in 100 objects, the true wealth of Scotland's material culture might be fully appreciated.

one MEDIEVAL STIRLING

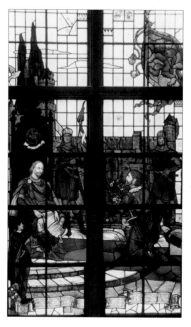

Alexander II presents trading privileges to Stirling, 1226. (Stained glass stair window, Municipal Buildings, Corn Exchange, 1917)

STIRLING MUNICIPAL BUILDINGS, designed by the architect John Gaff Gillespie (1870-1926), were embellished with sculpture, stained glass and murals which referenced the significance of Stirling's history at every level. The building had its difficulties. The foundation stone was laid by King George V on 11 July 1914, a few weeks before the outbreak of the First World War. The bad feeling in the burgh towards the expenditure when so many people were living in slum conditions meant that the foundation stone ceremony was done by remote control, with the king safely positioned at the County Buildings in Viewfield Place. On account of the war, the building was not completed until 1918.

The stair window dominates the main entrance. Executed by William Meikle & Sons of Glasgow, it bears the title 'King Alexander II presenting to his Burgesses of Stirling a weekly market and Merchant Guild, 18 August 1226'. The Provost kneels to receive the charter; warriors stand with the Lion Rampant and St Andrew's Cross.

Stirling people have always been conscious of having the privilege of 'royal burgh' status, and the kings and queens of Scots in regular residence in the palace of Stirling Castle. On the wall sconces for the electric lights on the staircase are shown their names: Alexander I, II and III. David I and II. William the Lion. Robert the Bruce. James I, II, III, IV, V and VI and Mary Queen of Scots.

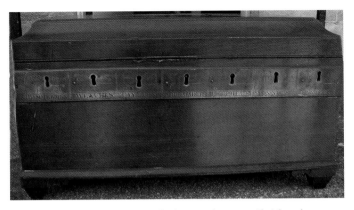

Box of the Seven Incorporated Trades. (Nineteenth century, with eighteenth-century engraved plate)

THE SEVEN TRADES of the Burgh of Stirling date back to medieval times, and were largely trades which grew in the service of the Royal Court in the castle. They are as follows: Hammermen (ranging from goldsmiths to blacksmiths), Weavers, Tailors, Shoemakers, Butchers, Skinners and Baxters (Bakers). The Stewart kings had other arrangements in regards to building and medical provision, so there are no mason, barber or surgeon incorporations as there were in other towns.

The box was made of mahogany by John Fisher and has seven numbered locks, one for an office bearer from each of the Trades. The box was first used on 3 October 1829, but replaces earlier boxes; it incorporates the eighteenth-century engraved key plate, made by John Christie, Gunsmith, in 1759. He was one of the famed Doune pistol makers whose engraving work was greatly prized.

The purpose of the box was to hold the Blue Blanket of the Seven Trades. This ancient banner is said to have been designed and made by the ladies of the court of Mary, Queen of Scots, and presented to the Trades. One of the oldest textile pieces in the Smith collections, it is in such a fragile state that it cannot be unwrapped without damage.

It is made of fine silk, and measures 9ft by 7ft 9 inches. It is in effect, a giant St Andrew's Cross or Saltire, hand sewn, in strips of cloth which are 10 inches wide. The unfurling of the Blue Blanket in times of crisis was a call to arms. If unfurled at the Cross in Broad Street, the Trades had to appear immediately to defend the burgh.

Robes of the Dean of Guild, 1886.

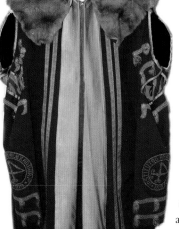

THE DEAN OF Guild has been head of the Merchants in Stirling since medieval times.

The main body of the robe is of fine wool flannel, and the trimmings are Ottoman silk. The embroidered details have been rendered in gold wire braid. The fur collar is coney, or lapin – simply rabbit fur, but treated with dye to give it a striped effect and a much more luxurious appearance. Altogether, it is a very fine production, probably done by an Edinburgh tailor who was a military or academic specialist. This robe replaces earlier robes, and was presented to the Smith in 2006 when a new robe was obtained.

The tailors in Stirling were a powerful organisation before the Union of the Crowns in 1603, when the Royal Court moved south. Even so, the deacon of the Tailors' Incorporation, one John Allan, who became a burgess and guild brother in 1520, was severely reprimanded by the Provost and baillies in 1524 because he had ornamented a gown with new fur. The Incorporation of Skinners raised a complaint that this was their job. The magistrates decreed that 'nae taylour within the burgh shall occupy the furrier craft, under the pain of 40/- to the Rude work as a fine'; i.e. 40/- was to be paid to the building work of the Church of the Holy Rude, every time this law was broken.

The predecessor of this gown was probably made both by a tailor and a skinner and it had to be very finely done, as the Dean of Guild, next to the Provost, was the most important person in the Royal Burgh of Stirling.

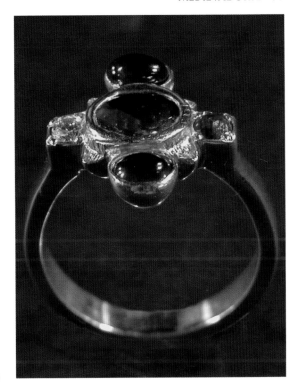

The Guildry Ring.

THE ANCIENT GUILDRY Ring is probably the oldest extant treasure in Stirling, dating back to a grant of David II, son of Robert the Bruce in 1360. King David II confirmed the 1226 charter of his predecessor Alexander II. As later documents show time and again, this ring came with the confirmation charter of David II in 1360.

The ring is set with five jewels arranged in the form of a cross. The centre has a paste emerald, with a purple stone on one side and a ruby on the other. Above the emerald is a purple garnet, and a smaller sized crystal lies below. The ring weighs half an ounce and the hoop is of pure gold; it has never been worn as a finger ring.

A tourist publication of the early nineteenth century describes how 'the Dean of Guild, when installed into the office in the Guild Hall, has a ribbon thrown around his neck, at which is suspended a very ancient gold ring set in precious stones'. Later on, as ribbon after ribbon wore out, the ribbon was replaced with a gold chain. This was in 1822 when a chain and medal were obtained for the Dean of Guildry.

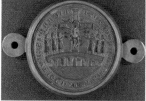

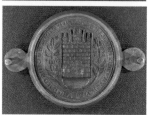

The Stirling Seal. (Nineteenth-century bronze matrix, to replace earlier matrix)

THE EARLIEST KNOWN example of the seal of the Burgh of Stirling dates to 1296, and the images from it have been well used as the insignia of the royal burgh, and now the city of Stirling, since that date.

On one side of the seal is a simple depiction of a castle. On the reverse side is a bridge surmounted by a crucifix, with armies on opposite sides. The Latin inscription around the rim reads: 'In this is contained the Castle and Bridge of Stirling / Here stand the British saved by their arms; here the / Scots, saved by the Cross.'

The implicit message is that although the invaders have force and strength, the Scots have God on their side. Like the image on the Seal, we know that the medieval Bridge of Stirling was made of wood and had seven arches and eight pillars. Archaeological investigation undertaken by Dr Ron Page in the late 1990s located the remains of several of the wooden piers in the Forth. The medieval bridge crossed the water diagonally probably to allow for the tidal currents.

In the nineteenth century, the Stirling Seal was remembered by a little poem:

> The Britons stand by force of arms / The Scots are by this cross preserved from harms / The castle and the bridge of Stirling town / Are in the compass of this seal set down

The inscription on the seal should be seen in the context of the medieval perception of Stirling, which was so graphically expressed in the map of the British Isles (now in the British Library) drawn up by Matthew Paris of St Albans in 1250. Scotland was thought to be a peninsula, surrounded by water (the marshy estuaries of the Forth and Clyde on the east and west) on three sides. The only way of reaching 'Scotland across the Sea' (*Scocia Ultra Marina*) was by the bridge of Stirling – Estrevelin Pons. Stirling was thus a frontier town, and every invading army headed for Stirling Bridge, where the castle stood sentinel over the crossing point. It was often said that 'to take Stirling is to hold Scotland'.

Stirling Castle did not lose its strategic purpose until the military moved out in 1964.

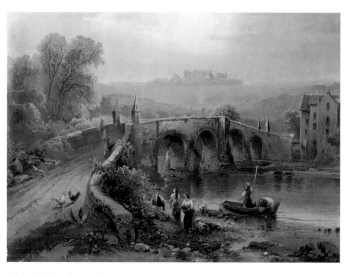

Stirling Bridge. (Oleograph, c. 1870)

BUILT IN THE fifteenth century to replace an earlier wooden bridge, Stirling Bridge is a rare and picturesque survivor. Before the Stevenson bridge was built in 1835, it was the only way across the Forth at Stirling, and the main route through Scotland from south to north. The Burgh Seal of Stirling, dating from the 1290s, shows the castle on one side and the bridge on the other. The main travel and trading route provided by the bridge was protected by the castle above; the bridge and castle together were the reason for Stirling's existence. This charming, hand-coloured print from the 1870s shows the physical relationship between the two.

The five-storey Scottish baronial tenement which graced the north end of the bridge for at least a century was a sore loss to the landscape when demolished in the 1960s.

When this view was painted, the Stevenson bridge was channelling most of the traffic, then as now. Note the group of women in the centre foreground, hanging their washing on the bushes beside the riverbank.

There is no artist's signature to this work.

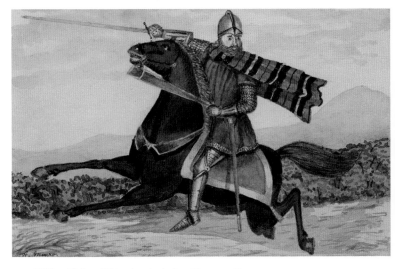

William Wallace. (Watercolour by Andrew Munro, 1908)

WILLIAM WALLACE IS the greatest Scottish hero of all time. Without Wallace and his victory at the Battle of Stirling Bridge in 1297, there would have been no Scotland. His courage, endurance and sacrifice has been a great inspiration to Scots worldwide, and to others fighting for freedom elsewhere.

No paintings or images survive from the time of Wallace. We do not have a clue about his appearance, save for the very general description given by his biographer, Blind Harry. Yet there are hundreds of illustrations, portraits and statues of Wallace.

Pictured here is a portrait of Wallace by Andrew Munro, a Scot living in Brooklyn, New York in 1908. Having no book of his own, he wrote a long poem about Wallace, which took thirty-six years to complete. It is illustrated with eleven watercolours by the author, showing Wallace as a dashing Highlander in bright tartans. The manuscript and illustrations were sent to Scotland in 2005 and purchased for the Stirling Smith.

Blind Harry. (Plaster, Alexander Stoddart, 1996)

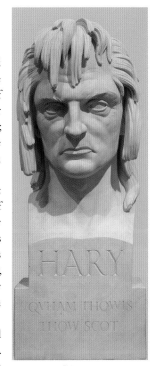

NOT A LOT is known about Blind Harry (also known as Hary), the Scottish poet who, in twelve books of verse, wrote of the acts and deeds of Sir William Wallace. Wallace died in 1305; Harry was writing in the 1480s, so the accuracy of his history has always been questioned.

Harry's aim was to write a great epic work of literature, extolling the life of Wallace, rather than the kind of history which is written today. His poem is the longest work in the medieval Scots language. According to Blind Harry, Wallace was instructed by St Andrew himself to liberate Scotland, and given a sword to do so.

Both Wallace and Harry lived before the time of portrait painting. This modern bust was created for the Stirling Smith by sculptor Alexander Stoddart in 1996. Since then, Stoddart and his work have become world-famous. In 2009, he became Queen's Sculptor in Ordinary, and was given the freedom of Renfrew, where he is Professor at the University of the West of Scotland.

The bust was cast in bronze in Powderhall Foundry, Edinburgh in 2009, thanks to the sponsorship of patrons Eileen and Ian White. It was unveiled on St Andrew's Day by Dennis Canavan, the Stirling politician who initiated the St Andrew's Day Public Holiday (Scotland) Act of 2007.

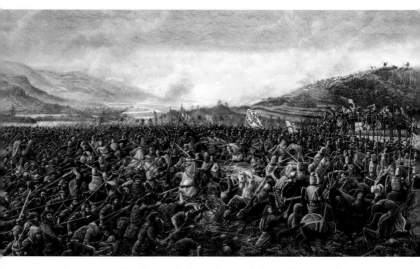

The Battle of Stirling Bridge. (Acryllic on board by Andrew Hillhouse, 2000)

THE BATTLE OF Stirling Bridge, 11 September 1297, was a great Scottish victory against one of the best-equipped armed forces in Europe. It was won by William Wallace and Sir Andrew de Moray fighting a large invading English army led by Edward I's treasurer, Hugh Cressingham, and his general, John de Warrene, Earl of Surrey.

The story of how Wallace and Moray took advantage of the geography, waiting until a portion of the English army crossed the bridge onto the narrow Causeway, then attacked, trapping them in the marshy surroundings of the Forth, is very well known.

The victory gave rise to songs and poems in Latin, and many artists in recent years have attempted to depict the scene. Andrew Hillhouse is an architectural draughtsman with a strong interest in the War of Independence.

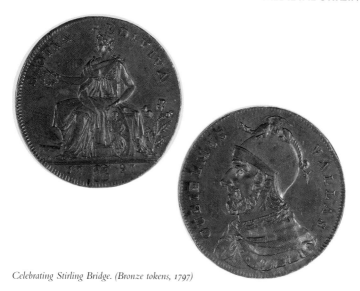

Celebrating Stirling Bridge. (Bronze tokens, 1797)

THE 11TH SEPTEMBER 1297 was the date of the Battle of Stirling Bridge. Wallace's famous victory against the English has been celebrated or commemorated in one way or another – in song, poetry and story telling – every year since.

In 1797, Colonel William Fullerton of Ayrshire commemorated the 500th anniversary by striking these tokens. On one side is William Wallace, the helmeted warrior, and on the other side 'Scotia Rediviva' – Scotland Resurgent, with her thistle and St Andrew's Cross, looking like a northern Britannia. A very nervous British government, fearing a Scottish uprising, took swift action, punishing Fullerton and demanding the withdrawal of the tokens, as they were very similar to the contemporary coin of the realm, with Britannia on one side and George III on the other. In the aftermath of the French Revolution, it was feared that the French would invade to help the Scots win their freedom. Stirling Castle garrison was strengthened against that possibility.

Only 500 of these tokens were struck, and they are now very rare. In 2008, Stirling man and coin expert Alex Brown spotted these at a coin sale, and alerted the Stirling Smith, facilitating the purchase for the public collections.

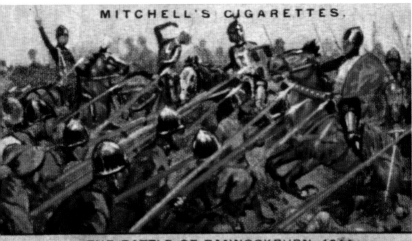

Bannockburn. cigarette card, 1930s.

THE BATTLE OF Bannockburn, 23-24 June 1314, was won by King Robert the Bruce against the invading army of King Edward II, and secured Scotland's future as an independent nation. It brought to a conclusion the war with England which had lasted nearly twenty years.

Among the images representing the battle in the Smith's collection is this little cigarette card, issued with Mitchell's cigarettes in the 1930s. The card was one of many artefacts gifted by the late Bob McCutcheon (1939-2002), the Stirling historian and bibliophile, to the Smith. As Scottish history was rarely taught in schools in the early twentieth century, the history cards issued by Mitchell played a significant part in keeping the past in the public eye.

Stephen Mitchell's tobacco company was established in 1724, and the family funded the building of the Glasgow Mitchell Library, one of the biggest reference libraries in the world today. The last Stephen Mitchell owned the estate of Boquhan at Kippen, near Stirling. He travelled to Glasgow by train every day, as did his cook, with fresh vegetables from the estate, to prepare the master's lunch. The community rooms in Kippen were also funded by Mitchell.

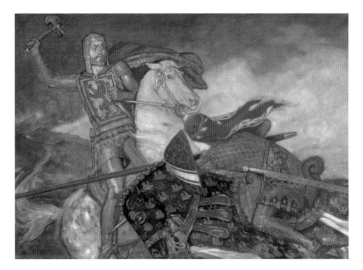

Bannockburn, 23 June 1314. (Tempera on canvas by John Duncan, 1914)

THIS PAINTING SHOWS the first blow struck at the Battle of Bannockburn. Sir Henry de Bohun (pronounced 'Boon'), nephew of the Earl of Hereford, recognised King Robert the Bruce and galloped against him at full speed with his lance. Bruce, mounted on a small grey horse stepped aside and swung his axe so hard that it split de Bohun's helmet and 'clove skull and brain' before the shaft broke. This was the start of a two-day battle which secured Scotland's independence after a war with England lasting nearly twenty years.

The opening blow of Bannockburn is remembered in a little rhyme used by Kings of Wishaw on their Battleaxe Toffee in the 1930s:

> Bruce and de Bohun, were fightin' for the croon,
> Bruce taen his battle-axe and knocked de Bohun doon.

The painting by the artist John Duncan (1866-1945) was an entry in the art competition of 1914, held in Glasgow to commemorate the 600th anniversary of the Battle of Bannockburn. It was bequeathed by the artist to the Smith.

The art competition was vigorously opposed by anti-nationalist elements within Glasgow Corporation and when the winning work, a disappointing image by the English artist John Hassall, was unveiled, it was dubbed 'the false Bannockburn'.

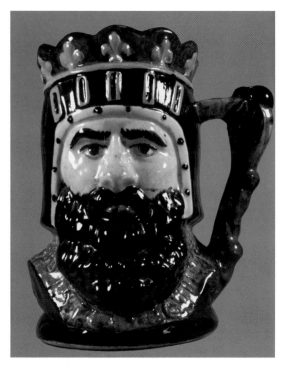

*Robert the Bruce.
(Govancroft Pottery
jug, 1964)*

KING ROBERT THE Bruce is one of the great heroes of Scottish history. His victory at Bannockburn secured Scotland's independence, and the day of the Declaration of Arbroath, 6 April 1320, when the Scottish nobles and churchmen made clear to the Pope that Robert was King of Scots by their choice, is now celebrated as Tartan Day in America.

Since 1964, the great statue of Bruce at Bannockburn by the sculptor Pilkington Jackson has become the most widely recognised image of Bruce. This little character jug records the popularity of an earlier icon. The jug was made in the Glasgow Govancroft Pottery, probably in the early 1960s, and is modelled on the face of the Bruce statue by Andrew Currie of Darnick, erected on Stirling Castle esplanade in 1877. The potter has added a spider on the handle of the jug, referring to Bruce resolving to follow the example of the spider to 'try, try and try again'.

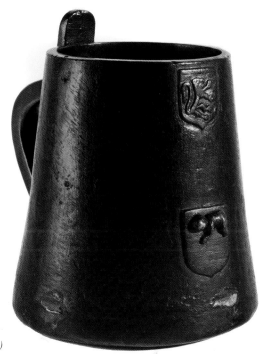

The Stirling Jug.
(Gun metal, 1511)

THE STIRLING JUG or Scots Pint is one of the oldest artefacts of the Royal Burgh of Stirling. Recent investigation by specialist staff at the National Museum of Scotland has dated the Stirling Jug to 1511, when it was manufactured at Edinburgh Castle by Robert Borthwick, who was 'maister meltare of the kingis gunnis'. Borthwick's main job was casting cannons for the defence of the realm, and the demand for accurate casting of measures could be met by his workshop.

The Stirling Jug was the national standard for liquid measure, and was held by Stirling as the burgh was in the centre of a thriving brewing industry. It was first instituted by Act of the Scottish Parliament in 1457. The jug held the equivalent of three imperial pints. It has the symbol of the lion rampant, and another image which is thought to be that of the Christ Child. When later copies were made after the Reformation, the symbol was changed to that of the Stirling Wolf.

Before being deposited in the Smith, the Stirling Jug was an important piece of burgh insignia, often paraded in civic processions.

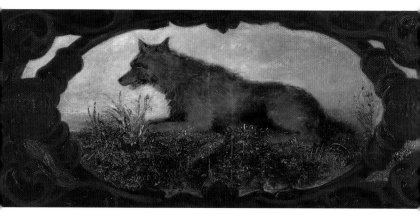

The Stirling Wolf. (Oil on canvas, 1704, artist unknown)

STIRLING AND ROME are two cities which share a common beast in their city mythology: the wolf. The she-wolf which suckled Romulus and Remus, the founders of Rome, and the couchant or seated wolf, which howled, alerting people to a Viking raid on Stirling, both feature on the buildings in their respective cities.

The earliest representation of the Stirling Wolf is thought to be on the Stirling Jug. The oil painting of the Wolf is eighteenth century. More modern wolves feature on the Wolfcraig Building in Port Street/ Dumbarton Road and on the weather vane (by artist blacksmith Robert Hutchison) on a building in Murray Place.

Although the wolf was Stirling's symbol, it was regarded as a predator to be hunted and exterminated. In 1288 an allowance was made for 'two park keepers and one hunter of wolves at Stirling' on account of the threat to the animals in the King's Park. In 1427, the reward for killing a wolf in Scotland was a shilling. There are many stories in different areas of Scotland regarding the hunting of the last wolf, and the species was exterminated in the 1740s.

The work was painted for the new Stirling Tolbooth or town house in 1704. It was removed to the Smith for safe keeping in the 1990s. The Tolbooth is now Stirling's centre for music and the arts.

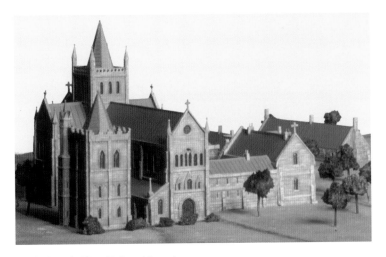

Cambuskenneth Abbey. (Scale model, 1997)

THE ABBEY WAS one of the great medieval religious houses of Scotland and part of the Augustinian order which included foundations in St Andrews, Inchcolm and Inchmaholm. Founded by David I in 1147, it was dedicated to St Mary the Virgin of Stirling and was well endowed with land and property. It was situated on one of the fertile bends of the River Forth. The Abbey had a close working relationship with Stirling Castle and the abbots served the royal household as secretaries and diplomats. One of them, Alexander Milne, was appointed the first President of the College of Justice, set up by James V in 1532.

Meetings of the Scottish Parliament were held there from time to time and King James III was buried there, after his death at the Battle of Sauchieburn in 1488.

Apart from the river, Cambuskenneth had no defences and was sacked by several invading armies. After the Scottish Reformation of 1560, the Abbey was given to the Earl of Mar, and was used as a stone quarry.

Very little of Cambuskenneth remains, apart from a stone bell tower which probably survived because it had other functions. This model is the only complete representation of the Abbey.

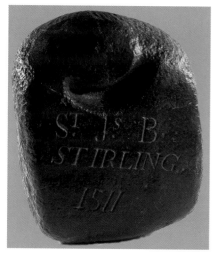

The world's oldest curling stone.

THE SMITH IS well known for having the world's oldest football. Curling enthusiasts also know it well as the home of the world's oldest curling stone and, for generations, visitors from North America have come to see it. In 2006, it was present for the 50th Anniversary: Canada to Scotland Rotary Curling Tour, which started in Stirling.

The stone is made of black basalt and is inscribed 'St Js B Stirling 1511' on one side, and 'A Gift' on the other. It is a 'loofie' in style, meaning without a handle, but with a channel for driving it across the ice. It weighs 26lb.

The curling stone is one of the oldest items in the Smith collection. It came from the collection of antiquities made by John McFarlane (1785-1868) for his museum in Bridge of Allan. The stone was discovered during work in the Milton Bog, where it was undoubtedly lost, through the ice, during a game.

Due to the Scottish climate, the game of curling originated here. It could be played on any convenient stretch of frozen water, and was reliant on skill, rather than equipment. Bonspiels or Grand Matches take place locally on the Lake of Menteith when 7 inches of ice forms and the lake freezes over. This last happened in 1979 and (almost) again in 2010.

Although curling is mainly confined to indoor rinks in this age of global warming, Stirling schoolchildren know that 'it's cool to curl'!

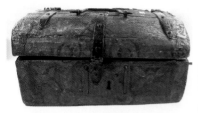

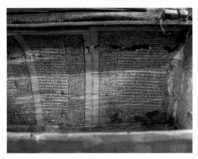

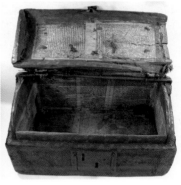

Stirling Burgh Box.

A SMALL WOODEN box, in the ownership of Stirling Burgh from time immemorial, has revealed its innermost secrets. Until recently, it was believed that the interior was lined with pages from a printed Bible. An examination by liturgical specialist, linguist and musicologist Dr Jamie Reid-Baxter has shown that the pages come from a Book of Hours according to the Sarum Rite, dating to 1503. The content of the pages are concerned with devotions to the Blessed Virgin Mary.

Episodes depicted include the Seven Joys of the Blessed Virgin, the Death of the Virgin, and the Marriage Feast at Cana. These devotions were important in medieval times. Robert Carver, composer for the Chapel Royal in Stirling, set the Seven Joys hymn for five voices, and court poet William Dunbar wrote a seven-verse hymn in praise of the Virgin. The box is a faded token of the cultural riches of Renaissance Stirling.

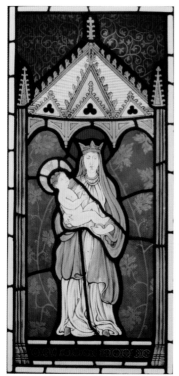

Our Lady of Cambuskenneth. (Stained glass, 1997)

SINCE MEDIEVAL TIMES, 25 March has been celebrated as the feast of the annunciation – the day on which the Angel Gabriel announced to the Blessed Virgin Mary that she would give birth to the son of God. Many churches were dedicated to the Virgin Mary. One of the main entry routes into medieval Stirling was through the Mary Wynd and even in the nineteenth century, a Protestant church built there was known as Mary Kirk.

Cambuskenneth Abbey, also known as the Abbey of St Mary of Stirling, was one of the most important abbeys of its kind, serving the Royal Court in Stirling. King James III and his queen were buried there.

Cambuskenneth Abbey was destroyed by the Scottish Reformation of 1560 and used as a stone quarry thereafter. This stained glass panel was created by artist Yvonne Smith, using the images of the Virgin Mary as she is depicted on the seals of the various Abbots of Cambuskenneth.

Decayed stained glass and lead fragments were found in the Cambuskenneth excavations in 1866, and it is likely that the Virgin Mary was depicted in it, as well as being represented by a sculpture in the church itself.

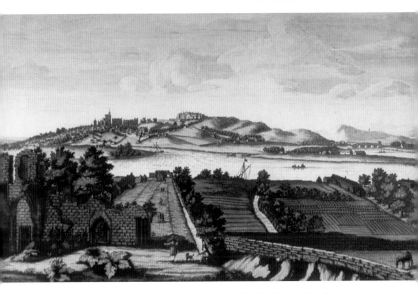

The Prospect of the Town of Sterling from the East, 1693, by John Slezer. (Tinted engraving)

THE LOOP OF the Forth, on which Cambuskenneth Abbey and village are situated, is one of the most fertile sites in the entire county. A local saying claims that 'a loop of the Forth is worth an earldom in the north'. This view of Stirling from the east in 1697 is taken from Cambuskenneth looking across the Forth. The ruined Abbey is on the left and the gardens and orchards of Cambuskenneth can be seen clearly.

Cambuskenneth was well known for its fruit, as the present day street names of Ferry Orchard and St James Orchard remind us. The Berry Fair, when the gooseberries were fully ripe, was a great day out for the people of Stirling, who crossed on the ferry to buy fruits of all sorts, laid out by the villagers.

The Ferry Boat operated seven days a week and the short ferry trip from Riverside to Cambuskenneth was the cause of a major local industry. However, seedsman Peter Drummond (1799-1877) was so concerned by the desecration of the Sabbath in Cambuskenneth, with day-trippers taking a Sunday outing from Stirling, that he started a leaflet campaign against it in 1848. This grew into the Stirling Tract Enterprise, a major publishing house which remained open until 1981.

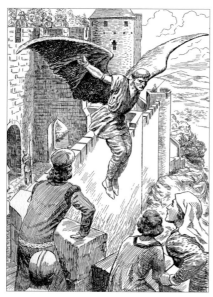

John Damian's Flight. (Drummond Tract image, c. 1900)

THE EARLIEST KNOWN flight experiment in Scotland took place from the walls of Stirling Castle in 1507. In Renaissance Europe, Leonardo da Vinci and others had studied the flight of birds and planned to build flying machines. Leonardo's experiments were done in the period 1498-1504, and none were recorded as successful.

John Damian was an alchemist, possibly with an Italian background, employed at the court of King James IV in Stirling. His flight, with a pair of giant wings, ended with a broken leg. He claimed that this was because of the use of hens' feathers in the wings, 'which covet the middens and not the skies'. The court poet William Dunbar wrote a long satirical poem, claiming that every bird of the air had attacked Damian in protest. James IV had funded Damian from the revenues of the Tongland Abbey in Dumfriesshire, earning the alchemist the nickname of 'the fenyeit (false) friar of Tungland'.

Renaissance scholar Professor Charles McKean of the University of Dundee believes that John Damian landed in the grounds which are now part of the Stirling Smith, and that if the flight had been a total failure, he would have broken his neck as well as his leg.

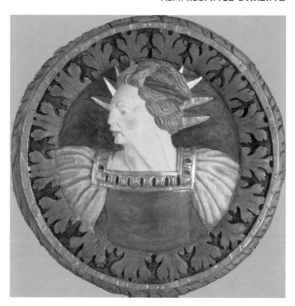

*Stirling Head,
c. 1540. (Painted
resin copy)*

THE STIRLING HEADS are a series of fifty-six or more carved oak
medallions made for the roof of the King's Presence Chamber in the
palace of Stirling Castle, built by James V (1514-1542). They comprise
one of the finest artistic expressions of the Scottish Renaissance.

The ceiling was destroyed by the army resident in Stirling Castle
in 1777, and many of the Heads were used as firewood. A century
later in 1874, the remaining Heads became the properly of Stirling
Smith. Following a fundraising campaign in 1922-3, other Heads in
private ownership were brought back to Stirling. In 1970, a collection
of thirty-one Heads were returned to Stirling Castle by the Smith
Trustees.

The subjects range from people at the court to figures from classical
mythology, such as the god Apollo, with the rays of the sun streaming
behind his head.

It is only in the last five years that those involved in the reconstruction
programme, in Stirling Castle, have come to agree that the Heads were
painted originally. Scrubbed clean by earlier generations, the detailing
on the Heads registers clearly when paint is applied to the copies.
The constant comment with respect of this Head of Apollo is its
similarity to former Prime Minister, Margaret Thatcher.

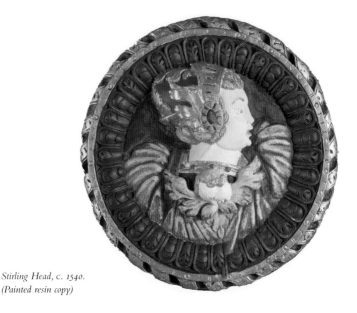

Stirling Head, c. 1540.
(Painted resin copy)

THE ONGOING HISTORICAL reconstruction of the Palace in Stirling Castle involved the re-carving of all the existing Stirling Heads, by wood carver John Donaldson in 2004-10. During that time, the Heads have been studied closely by a number of different experts.

The subject of this portrait is likely to have been a lady of the Stewart court. The winged cherub on her breast is a symbol of mortality of the type seen on gravestones and memorial slabs of the time, and it is likely that she died when the ceiling was being made. Another interesting feature is that the marks on the inner rim have been identified as musical notation suitable for a harp or clàrsach, and musical experts have successfully played the notes. Perhaps the music was there to accompany her soul to heaven.

The quality of the music and poetry at the courts of King James IV and his son James V was high. Robert Carver (*c.*148-*c.*1570), composer to the Chapel Royal in Stirling Castle, was an outstanding musician whose work, suppressed by the Scottish Reformation, has been re-discovered for new and appreciative audiences over the last forty years. Poets such as William Dunbar, Blind Harry and Sir David Lindsay, who served at the court in Stirling, have left a rich literary legacy also.

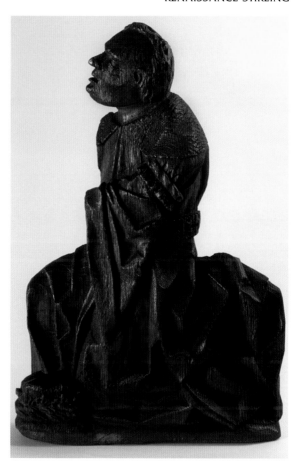

Carved oak fragment, Earl of Fife, from Stirling Castle.

THIS IS ONE of many pieces of carved oak panelling from Stirling Castle, dispersed in the eighteenth century and now in the Stirling Smith collections. It was identified by heraldic artist Dr Patrick Barden as part of a sequence depicting the coronation ceremony of a Scottish king, possibly from the Chapel Royal of Stirling Castle. The Earls of Fife had the hereditary duty of placing the crown on the head of the king, and one is shown here in a rich fur robe with the crown at his feet. The imperial arch on the crown indicates that it is no earlier than the reign of James V (1514-1542), for whom the royal palace in Stirling Castle was built.

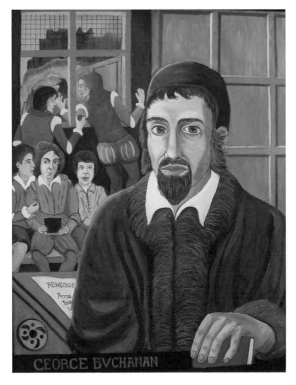

George Buchanan (1506-1582).

GEORGE BUCHANAN, BORN at Killearn in West Stirlingshire, is one of the most famous Scots of all time.

He was a scholar, teacher, poet, playwright, humanist, diplomat, politician and historian. He was court poet to Henri II of France and to Mary, Queen of Scots. He even taught young King James VI in Stirling Castle.

In his lifetime he was so well known that a letter (now in the National Library of Scotland) sent to him from Europe was simply addressed to 'George Buchanan, the most learned man in every respect, Edinburgh in Scotland'.

Only four portraits of Buchanan survive and all were painted in the last years of his life. This particular reconstruction in the Smith collection shows a young Buchanan, at the age of thirty-two, teaching King James V's children in Stirling.

George Buchanan and Mary, Queen of Scots.

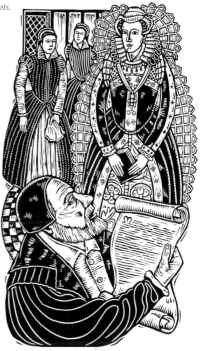

GEORGE BUCHANAN WAS a poet and dramatist, as well as a political thinker. He produced many masques, plays, poetry and music for the Royal Courts of France (when Queen Mary was married to Francis II) and Scotland.

As Mary, Queen of Scots grew up in France, and Buchanan had spent much of his adult life there, they had a natural rapport. They both loved poetry and litera-ture, and Buchanan read the Classical authors to her.

When a prisoner of the Portuguese Inquisition, he had paraphrased the Psalms of David in Latin. When they were first published, he dedicated the Psalm Paraphrases to her. These works were so fine that several European composers, notably Jean Servin (1529-1609) of France and Statius Olthoff (1555-1629) of Rostock set them to music. Modern editions of these were published by Professor James Porter of Stirling in 2007.

The illustration of Mary and Buchanan is from a series of lino cuts by Stirling-based artist Owain Kirby, commissioned to commemorate the 500th anniversary of Buchanan's birth in 2006. Kirby is an artist who has worked closely with Smith staff to illustrate and contextualise Stirling's history.

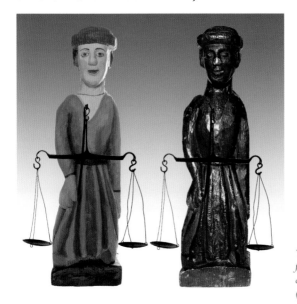

The figure of Justice from the courtroom of Stirling Tolbooth. (Oak, c. 1500)

TRADITIONALLY, JUSTICE IS blind. She wears a cloth over her eyes and judges the cause by the balance of her scales. The figure of Justice from the courtroom of Stirling Tolbooth is so old that she does not have a blindfold, and stares straight ahead.

Made from a solid oak block, Stirling's Justice has possibly been created from a pre-Reformation (pre-1560) altar figure. She bears stylistic resemblances to northern French altar statues of that date. Her scales have been crudely pushed into her right hand.

Stirling Tolbooth was re-built in 1704 but the statue seems to have come from an earlier building. When she was retired to the museum collection in the nineteenth century, a plaster copy was made for use in the principal court of Stirling Sheriff Court, where it remained until it was accidentally broken in the late 1980s.

A new resin copy was made so that the detailing of the carving could be painted to register the features of this curious piece.

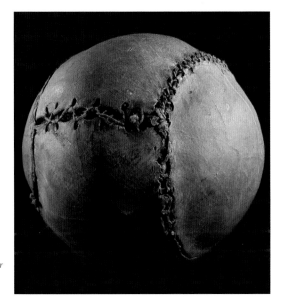

The oldest football in the world. (Pig's bladder encased in stitched leather)

MANY PEOPLE FIND it hard to believe that the oldest football in the world is in a small museum in Scotland, and that it is the property of the people of Stirling.

The story is simple. The ball must have been kicked high, at some time in the 1540s, and it became lodged in the rafters of the Queen's Chamber in Stirling Castle prior to the fitting of the ceiling. It stayed there undiscovered until the enabling works in 1970s, when it was gifted to the Smith.

Made of a pig's bladder, it would not otherwise have survived. The next oldest Scottish football, according to the National Museum, is from the eighteenth century.

Football was quite a rough sport in the sixteenth century and there were several pieces of legislation discouraging it, as it detracted from military service. A contemporary poem, 'The beauties of the foot ball', lists the disadvantages – broken bones, torn ligaments, crippling injuries and even impotence.

Football specialists throughout the world have acknowledged the significance of this ball, which took pride of place in the World History of Football exhibition in Hamburg in 2006.

Sword dollar of James VI.

JAMES VI WAS crowned in Stirling's Church of the Holy Rude in 1566 and raised in Stirling Castle, under the guardianship of the Earl and Countess of Mar. The present Earl of Mar still owns his cradle, which is on display in the National Museum of Scotland, as is his baby chair.

George Buchanan was in charge of James VI's education, and taught him Latin, Greek and Hebrew.

Buchanan was one of those who believed it was important for the young king to be raised in the Protestant faith as he had gained the throne following his mother's abdication, when he was only a year old. His mother, Mary, Queen of Scots, who had kept her Catholic faith, was imprisoned by her cousin, Queen Elizabeth 1 of England, after she fled Scotland, following an unsuccesful attempt to regain her throne. After nineteen years of incarceration she was executed in 1587.

Buchanan tried to teach James VI the rules of good kingship. In his book, *The Law of Kingship among the Scots*, Buchanan declared that bad kings should be deposed and that their assassination could be justified. This radical political thought was even expressed on the coinage of the young King James. The Sword Dollar has the Latin inscription, *'Pro me, si mereor, in me'* − that is the sword is to be drawn 'For me, but if I deserve it, in me'.

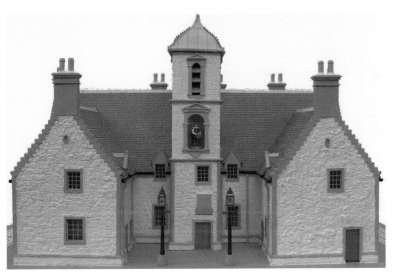

Cowane's Hospital. (Model by George W. Reid, 2005)

COWANE'S HOSPITAL IS one of the oldest and most distinctive buildings in Stirling. It was funded by the legacy of John Cowane (d. 1633) for the purpose of supporting twelve 'decayed gildbrothers, burgesses and indwellers of the burgh' and designed by John Mylne, the royal master mason. It was constructed between 1637 and 1648.

The building is laid out on an E-shaped plan with attractive crow stepped gables and adorned with a full size statue of John Cowane, carved from contemporary drawings. Affectionately known as 'Auld Staneybreeks', the statue is reputed to come alive every New Year's Day and dance a jig before returning to his plinth.

The Cowane's Hospital Trust is still a powerful charity in Stirling to this day. Although the building was never used as a poorhouse or hospital as intended, it has remained an important civic building. The Stirling Guildry has met there over the centuries, and many civic events take place there. The hospital retains its historic garden, together with a bowling green which is the oldest in Scotland.

The model of Cowane's Hospital was made by George W. Reid of Aberdeen and gifted to the Stirling Smith.

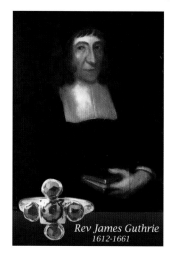

Reverend James Guthrie.

THE REVEREND JAMES Guthrie (1612–1661) was one of the most important church ministers in Scotland in the Covenanting era. His statue stands in the Valley Cemetery. The Stirling Smith owns his portrait and chair, and in 2004 purchased the gold and garnet ring which he passed to his niece before he ascended the scaffold to his execution on 1 June 1661. Since then his ring has passed through six generations of daughters of the Church of Scotland Ministers.

Guthrie was a distinguished scholar and theologian and, from 1649, he was a minister in Stirling. The disagreement over Episcopal forms of church government led to the physical division of the Church of the Holy Rude into the East and West churches. This was only reversed in the 1930s.

An unrelenting critic of Charles II, Guthrie was depicted in an English cartoon of 'The Scots holding their young king's nose to the grindstone'. After the Restoration of the monarchy in 1660, Charles II had him executed. Guthrie laid down his life for his beliefs. A man of great faith, he preached a sermon before he was beheaded.

It may seem to us that Guthrie belongs to the distant past; however, in the Netherlands, his sermons are still read in some of the Protestant churches to this day when there is no Dutch pastor available to preach a sermon.

Guthrie's most recent biography was published in Dutch by Janny Bout and Nel Spaan in the year 2000, and his story is probably better known in Europe than it is in Stirling.

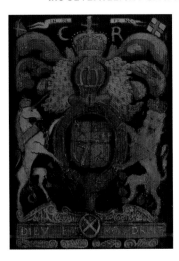

Royal Arms of Charles II. (Painted panel)

THIS WAS COMMISSIONED for the Tolbooth of Stirling after the Restoration of 1660. It was used as the emblem of royal authority under which the local court operated, a practice which continues in court rooms to this day. The payments for its production are recorded in the Treasurer's accounts, as follows:

- Item to Francis Dyer for drawing the King Arms to the Council House £16
- Item to Christopher Russell for making the board £2.18s

Dyer is recorded as painting various works in the town, including the statue of John Cowane ('Auld Staneybreeks') on Cowane's Hospital in 1675.

This is not the first image on the panel. Conservation work in 1997 indicated earlier shapes beneath, and X-ray plates taken at Stirling Royal Infirmary show that the positions of the horn and feet of the unicorn have been changed.

Christopher Russell, wright, was employed by the council in the 1660s and '70s making furniture, coffins and even hanging the hospital bell.

The panel was conserved with a grant from the Scottish Museum Council.

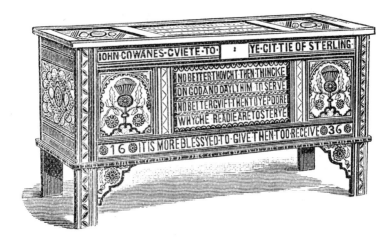

Cowane's Charter Chest, 1636.

STIRLING WAS ONLY awarded city status in March 2002. Nevertheless, it is one of the oldest burghs of Scotland, and governed by the Court of the Four Burghs (Edinburgh, Roxburgh, Berwick and Stirling), set up in the reign of King David I (1124-1153).

The maker of the Cowane's Hospital charter chest in 1636 clearly believed that Stirling was a city in his time. The chest, carved from oak, is inscribed:

> JOHN COWANES GUIFT TO YE CITTIE OF STERLING. I WAS
> HUNGRIE AND YE GAVE ME MEAT. I WAS THIRSTIE AND
> YE GAVE ME DRINK. I WAS A STRANGER AND YE TOOK
> ME IN. NAKED AND YE CLOTHED ME. I WAS SICK AND YE
> VISITED ME.

Cowane's bequest, of 40,000 merks of silver for the poor of Stirling, was a gift of which any city would have been justly proud. After 370 years, Cowane's Hospital still stands and the money continues to work for Ye Cittie of Sterling. The charter chest was a casualty of the Jacobite Rising in 1746, when it was taken by the retreating army. For over a century it was used as a meal chest. It was recovered by Stirling Dean of Guildry, Robert Stewart Shearer, in 1882, and brought back to Stirling.

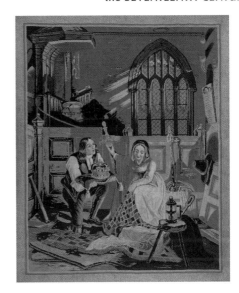

Hiding the Honours of Scotland, 1652. (Tapestry, 1850)

THE HONOURS OF Scotland (as the Scottish crown jewels are known) have been on display in Edinburgh Castle for all to see since 1819. They are a major tourist attraction.

The Honours consist of the crown, sceptre and sword of state, dating from the fifteenth century; in their life they have survived through tumultuous times. During the time of Oliver Cromwell, the Honours were housed in Dunnotar Castle for safety. Cromwellian troops, who were besieging the castle, had it in mind to destroy the Honours and to melt them down. In a daring rescue, Christian Granger, wife of the minister of Kinneff parish church, obtained permission to enter the castle to collect lint for spinning. She wrapped the sword and sceptre in the lint, hid the crown under her dress, and smuggled the Honours out of Dunnotar. She travelled the six miles to Kinneff, and, with the help of her husband, hid them under the floorboards of the church, where they remained until the Restoration of King Charles II in 1660.

The hiding of the Honours is shown in the tapestry, sewn in about 1850 by a thirteen-year-old ancestor of donor Margaret L.M. Martin. The image was probably copied from a print. There are 12,480 stitches, and the work would have taken a minimum of seventy-four hours to complete.

Following the Act of Union in 1707, the Honours were put in a box in Edinburgh Castle, being re-discovered by Sir Walter Scott in 1818.

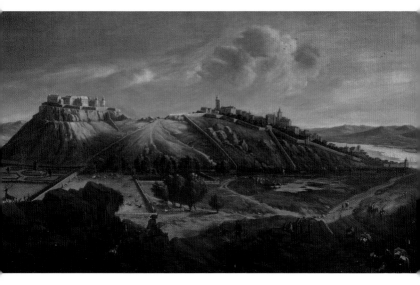

Stirling's oldest landscape. (Oil on canvas)

THIS PAINTING BY the Dutch artist Johannes Vosterman (1643-1699) is the oldest surviving oil painting of Stirling. Vosterman was court painter to King Charles II and this painting dates from the 1660s. The figures in the painting are thought to be by fellow artist Thomas Van Wyck (1616-1677), who has depicted the artist at work in the centre foreground. The other figures on the right are traders wearing tartans, heading towards the town gates. Stirling in this period was a centre for the manufacture and supply of the swords and pistols favoured by the Highlanders.

Then, as now, Stirling Castle dominates the landscape. With its function as a fortress and stronghold, the rock was kept clear of trees for reasons of security. The surrounding land belonged to the king. The Royal Gardens can be seen on the left, and in the walled enclosure of the King's Park, deer, wild white cattle and other beasts were kept as a food supply for the castle and a hunting opportunity for the Royal Court.

At this time, Stirling was an important port on the River Forth, with strong trading links with Veere in the Netherlands and the Baltic towns. The ships in the port can be seen on the far right.

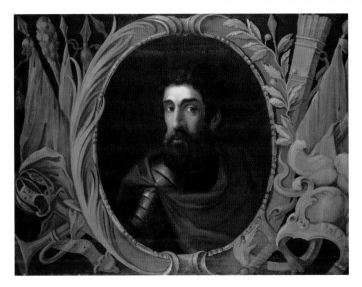

Wallace portrait, 1660/1720. (Oil on canvas, artist unknown)

THE OVAL CENTREPIECE of this work was painted for the decorative scheme commissioned by Sir John Wauchope of Niddrie Marischal House, Edinburgh, to celebrate the Restoration of Charles II in 1660. The oldest existing portrait of Wallace was commissioned for the coronation of Charles I in Edinburgh in 1633.

In the period 1720-30, Niddrie Marischal House was altered internally, and the Wallace portrait was set within a trophy of arms, to be the main picture above the dining room fireplace. It was seen here by writer, journalist and printer James Paterson, author of *Wallace and his Times* (Edinburgh, 1858), who had it engraved for his book. It was used as an illustration in several other books and became one of the best-known images of Wallace in the nineteenth century. Since the fire and demolition of Niddrie Marischal in 1959, the portrait has been in private hands.

When it came on the market in 2004, it was secured for the Stirling Smith after a major fund-raising campaign, with contributions from the Art Fund, the Friends of the Smith and 208 individuals, businesses and societies. The campaign was helped by a fund-raising song from folk singer Adam McNaughtan.

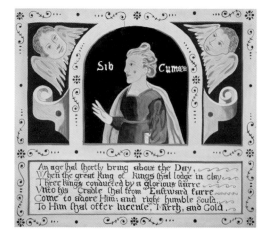

An age that shortly bring about the Day,
When the great King of Kings that lodge in clay,
Three kings conducted by a glorious starre
Unto his Cradle that from Eastward farre
Come to adore Him; and right humble souls,
To Him that offer Incense, Mirrh, and Gold.

The Stirling Sibyls.
(Painted panel)

THE SIBYLS WERE the ancient prophetesses of antiquity, the female pagan counterparts of the Old Testament prophets, whose writings were interpreted as predictions of the birth of Christ. Sibylline writings were included in the theological studies in universities throughout Europe in the sixteenth and seventeenth centuries, before they fell out of favour. Perhaps the best-known historical depictions of the Sibyls today is in the work of the black and white marble floor of Siena Cathedral in Tuscany, and in the paintings of Michelangelo on the Sistine Chapel ceiling in Rome.

The Cumean Sibyl shown here with her poem in Scots is from Livilands House, Stirling. She was part of a decorative scheme in the oratory, dating from about 1550-1620. However, the scheme was partially destroyed and covered over and it was only rediscovered in 1866; only five of the twelve Sibyls survive. When Livilands House was demolished to make way for Stirling Royal Infirmary, the panels were gifted to the National Museum of Scotland, where they are now on display.

The Stirling Sibyls are unique in Scottish interior decoration, and show that Stirling was very much part of mainstream European culture. Copies were made for the Stirling Smith in 2000 by artist Michael Donnelly, so that these important Stirling girls can continue to make an appearance in the city of Stirling.

Rare masonic stone.

WHEN NEW INFORMATION comes to light on objects in the Smith (or any other museum) collections, a reassessment has to take place.

This stone was gifted to the Smith by a family in Kippen in 1986. Through an accident with a coal lorry, it came to be in two parts. In the years preceeding the Second World War, it had been kept in a room in the Crown Hotel, Kippen. It was given temporarily into the keeping of artist Sir D.Y. Cameron (1865-1945) but returned after his death.

With no history of a masonic lodge in Kippen, the purpose of the stone was unknown. Masonic historian Tom McDonald, who in recent years supervised the refurbishment of that prominent Masonic Stirling memorial, the Christie Clock in Allan Park, has arrived at an explanation. The stone is an ancient form of the tracing board, used to initiate and instruct masons about freemasonry in a pre-literate age. The masonic statutes were introduced by James VI's master mason William Schaw (c.1550-1602). In 1599, there were only three masonic lodges in Scotland – in Edinburgh, Kilwinning and Stirling, where there was a royal building programme. It is likely that this is the instruction stone of the masons associated with Stirling Castle in the early seventeenth century.

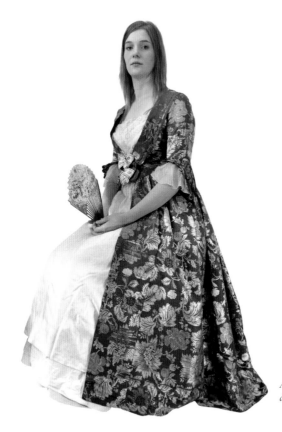

*A wedding dress
dating from 1742.*

THIS WEDDING DRESS dates from 1742 when Miss Anne Gillespie, daughter of the Provost Thomas Gillespie, was married. It was gifted to the Smith in 2006 by the Reverend Sam Yeo of Hexham, and following a programme of cleaning and conservation, it is now on display.

The conservation work was undertaken by Mrs Mary Eastop, who found some interesting information in the process. The wearer had put her foot through the petticoat, and a perfect repair patch was made. The dress was later let out, to accommodate a pregnancy, and taken in again.

The dress is made of Spittalfields silk brocade with fashionable half-length, scalloped-edged sleeves with white silk gauze trimmings. The open bodice is trimmed with bows, and the open robe has cream satin petticoats beneath. It is in splendid condition

Broadsword made by James Grant of Stirling.

THIS BROADSWORD, MADE by James Grant of Stirling, is one of only five of its kind and is marked 'JG' on the hilt. The blade itself is marked 'God Bless James III'. James Grant was journeyman to James Allan, sword maker of Stirling, but was in business for himself by 1759.

Sword and pistol makers were numerous among the local trades of Stirling prior to the ban on Highlanders carrying weapons after the Jacobite Rising of 1745-6. Many of the Stirling makers were supplying the Highland trade, hence the inscription for 'James III', the father of Prince Charles Edward Stuart and more commonly known as The Old Pretender or James VIII of Scotland. This sword also has the S-shaped decoration which is said to signify Stirling.

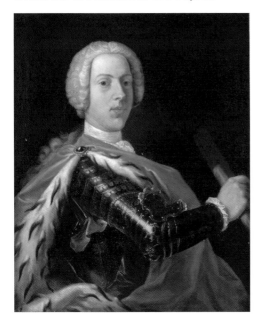

Portrait of Prince Charles Edward Stuart by Cosmo Alexander. (Oil on canvas, 1744)

BONNIE PRINCE CHARLIE led the 1745-6 Jacobite Rising which ended with the disastrous defeat at Culloden, 16 April 1746. His achievement in raising an army of Highlanders and sustaining it for so long was in no small measure due to the strong support he obtained from the great Jacobite houses which ringed Stirling – Bannockburn, Leckie, Touch, Arnprior, Polmaise, Lanrick, Balhaddie, Keir, Garden and Kippendavie.

This iconic portrait came from the house of the Seton Stuarts at Touch, and was painted by Cosmo Alexander. The Stirling Smith also has the punch bowl from which Bonnie Prince Charlie drank when he stayed at Bannockburn House. The pocket watch, owned by the farmer who guided him across the Forth at the Fords of Frew on his way south, is another Smith treasure.

These items, once in private hands, are now the property and common heritage of the people of Stirling.

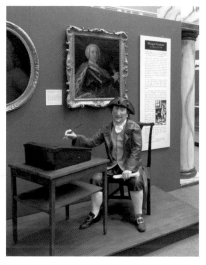

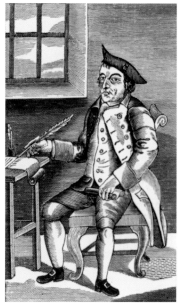

Right: *An engraving of Dougal Graham, Stirling's first war correspondent.*

DOUGAL GRAHAM (1724-1779), farm labourer from Raploch, was twenty-one years of age when he joined Prince Charlie's army as it crossed the Fords of Frew on its way south. He followed the army to Derby, then back north again to defeat at Culloden in April 1746. As he was barely 5ft tall and suffering from physical disabilities, he was a camp follower and not a fighting man.

He was a journalist in the pre-newspaper era and, in September 1746, he published his *History of the Late Rebellion* in rhyming verse, and was able to make a living selling copies of it round the country.

In the days before regular newspapers, chapmen like Dougal, who sold leaflets or 'chapbooks' with the latest news, were highly popular figures. Dougal's history was his first work, and he wrote and published many popular stories during his lifetime.

In 1772 he became Skellat Bellman or town crier in Glasgow. The Skellet Bellman made the ordinary announcements; the Deid Bellman announced deaths and funeral times. He is represented in the Smith by a life-sized portrait and woodcuts.

Two volumes of his works are in print, and he was greatly admired as the poet of the working people of Scotland by literary giants like Sir Walter Scott.

Street literature: A Stirling chapbook.

BEFORE THE ADVENT of regular newspapers and magazines, people got their news and their entertainment from a wide variety of irregular, and sometimes unreliable, sources. The 'Chapman billies', selling their chap or cheap books and news sheets were once a common sight in every town. There were also 'flying stationers', men with portable printing presses, who would follow the news, usually appearing in towns before public executions were to take place. They made a profit by printing the details of the crime and the execution, and sometimes scripted 'The Last Dying Confessions' of the prisoner. Several news sheets relating to the execution of the radical weavers Baird and Hardie in Stirling in 1820 still survive, although the story was also printed at length in the *Stirling Journal*, the town's first newspaper.

Two printers in Stirling, operating from the later eighteenth century and supplying the popular market well into the nineteenth century, were William Macnie and Charles Randell. Each issued many hundreds of chapbooks for sale. Shown here is a book by Macnie of 1825 with Jacobite stories and songs. Macnie, who operated from a close in Baker Street, later sold the business to Ebenezer Johnstone, who started the *Stirling Observer* in 1836.

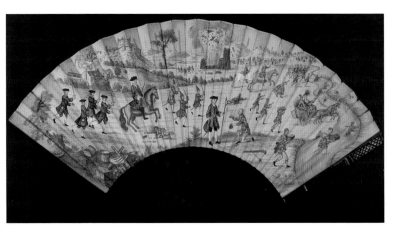

Siege of Stirling fan.

THIS RARE, FRAGILE witness to Stirling's military past was purchased in 2007, thanks to a generous Friend of the Smith and a grant from the National Fund for Acquisitions. As we know, the Provost and magistrates of Stirling were branded as cowards for surrendering the keys of Stirling and allowing the Jacobite army to enter.

When William Duke of Cumberland rode into Stirling, the Jacobite army retreated. The two armies did not meet until 16 April 1746, at the Battle of Culloden. The Jacobite army was slaughtered and Prince Charles fled. As way of reward, the Provost and magistrates of Stirling gave Duke William, 'Butcher Cumberland' the freedom of the burgh in a fine silver casket.

This fan commemorates Duke William's triumph and the Jacobite retreat. It even shows the accidental blowing up of St Ninian's Church (the tower alone was left standing and remains to this day), with all of the bodies landing in the graveyard, and the Jacobites fleeing over the Fords of Frew with treasure and provisions looted from Stirling. One of the treasures taken was the Cowane's Hospital Charter Chest of 1636, and this was not retrieved until 1882.

The events depicted on this fan happened on 1 February 1746, and, no doubt, many of the ladies of Stirling were using fans like this when Duke William was given the Freedom of Stirling in April 1746.

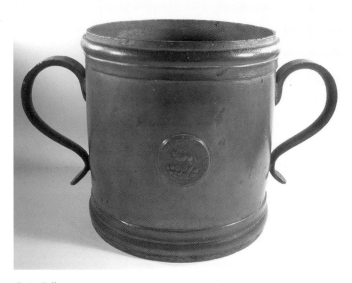

Grain Gallon, 1707.

FOLLOWING THE ACT of Union in 1707 when Scotland became part of Great Britain, the old weights and measures were discarded and new measures were adopted. The Grain Gallon which carries the couchant wolf, the symbol of the Royal Burgh of Stirling, was one of these. This was recently purchased with the help of Alex Neish, the pewter expert whose own collection is one of the world's biggest.

In Stirling, the pewterers came under the Incorporation of Hammermen, whose earliest minute book, dating from January 1596, is in the hand of pewter-maker Robert Robson, Deacon of the Incorporation.

Thanks to the generosity of specialists like Alex Neish, who take a personal interest in the Smith's collections, important acquisitions are still being made. The funding came from the National Fund for Acquisitions, with a matching amount from the Common Good Fund of Stirling.

The ancient key of Stirling.

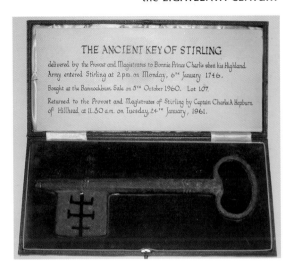

THE ANCIENT KEY OF STIRLING

delivered by the Provost and Magistrates to Bonnie Prince Charlie when his Highland Army entered Stirling at 2 p.m. on Monday, 6ᵀᴴ January 1746.

Bought at the Bannockburn Sale on 5ᵀᴴ October 1960. Lot 107.

Returned to the Provost and Magistrates of Stirling by Captain Charles A. Hepburn of Hillhead at 11.30 a.m. on Tuesday, 24ᵀᴴ January, 1961.

THE STIRLING SMITH Art Gallery and Museum collections are a window into Stirling's past. There is a range of historical keys in the collection, the most important of which is the key to Stirling itself, surrendered on demand to Prince Charles Edward Stuart on 6 January 1746.

On that day, Bonnie Prince Charlie was resident in Bannockburn House, and was preparing to lay siege to Stirling with his Jacobite army. The Provost and magistrates feared that the burgh would be sacked and that there would be great loss of life and property. Despite opposition from the people and being rebuked as cowards, the Provost and magistrates surrendered the keys – Stirling was still a walled town with ports or entry gates at this time – and the Jacobite army entered, without opposition, to lay siege to the castle.

However, the castle was well supplied with men and arms and under the command of General Blakeney, who sent the following message to the burgh council: 'Gentlemen, as your Provost and Bailies think the town not worth their notice to take care of, neither can I. I will take care of the Castle.'

The action of the burgh council was controversial, but it saved Stirling from being destroyed. The siege of Stirling Castle was raised when William, Duke of Cumberland, rode into town with his army on 2 February 1746. The key was returned to the Provost 215 years later by the connoisseur Charles A. Hepburn, owner of Red Hackle Whisky.

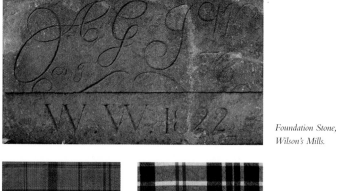

Foundation Stone,
Wilson's Mills.

Bannockburn
tartans.

TARTAN IS VERY much associated with the Highlands of Scotland, and
the Stirling Smith has an important collection of eighteenth-century
'hard' tartans. Few people outwith Stirling realise that Bannockburn
was the chief place of tartan manufacture from the mid-eighteenth to
the early twentieth century. The weaving and wearing of tartan was
banned in the Highlands by the Disarming Act after the collapse of the
Jacobite Rising of 1746. Bannockburn was technically in the Lowlands
and the Wilson family seized the opportunity by weaving tartans for
the new Highland Regiments, raised by the British government.

Tartan became a highly fashionable fabric after King George IV wore
a kilt during his visit to Edinburgh in 1822. Thanks to the popularity
this brought, tartan became a major industry in Bannockburn from
that date.

Nothing now remains of Wilson's Mills, except a solitary stone
engraved with the dates 1761 and 1822. This is in the grounds of the
Smith, thanks to the vigilance and generosity of genealogist and tartan
expert Tony Murray, who personally rescued the date stone during the
demolition in the late 1970s.

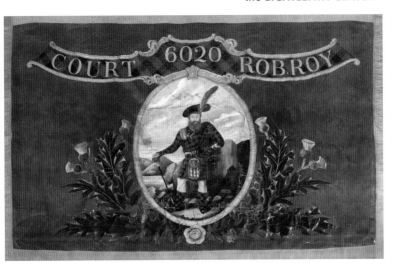

Rob Roy MacGregor.

THE BANNER OF the Rob Roy Court no. 6020 of the Ancient Order of Foresters is a recent purchase for the Smith collections, made with the assistance of the Stirling Common Good Fund.

The Ancient Order of Foresters is a British Friendly Society which had Scottish branches or Courts from 1839. At first it was a purely sociable society, until the members decided that they had a duty to assist their fellow men who fell into need 'as they walked through the forests of life'. This 'need' arose principally when a breadwinner fell ill, could not work and, therefore, received no wages. Illness and death left families financially distressed and often destitute. Relief of this need has been the main purpose of the Foresters. It was achieved by members paying, initially, a few pence a week into a common fund from which sick pay and funeral grants could be drawn. With the advent of the National Insurance scheme and the welfare state, many of the branches closed.

The choice of Rob Roy (1671-1734) as a figurehead for a Court of the Foresters was a natural one. Rob Roy cared for his family and clan in a creative way, raising money through the taking of black cattle and returning them for a rent or 'mail', a practice which is commonly known today as blackmail.

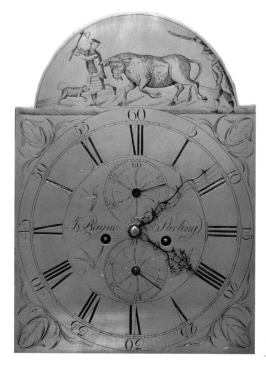

*Long-case clock crafted by
John Bayne, clock-maker.*

JOHN BAYNE QUALIFIED in 1777 and practised his craft as a clock-maker in Stirling until the 1790s. This engraved brass dial is from a long-case clock in the Smith collections.

The dial features a herdsman and a butcher, with a cleaver, trying to apprehend a bull. It was a sight which was probably common in Stirling at one time. John Bayne's workshop was in Spittal Street 'opposite Cowane's Yard'. A little further down the street was the slaughterhouse, which was removed in 1854, to make way for the High School of Stirling – now the Stirling Highland Hotel. When the slaughterhouse was in Spittal Street or 'The Back Row', the place was highly undesirable, with blood running down the street into the lower town. It was around Martinmass (11 November) that cattle were commonly slaughtered, as not many could be sustained through the winter.

After 230 years, Bayne's clock still keeps perfect time and the hours chime a welcome to Smith visitors. This is thanks to the ministrations of clock expert Charles Allan, author of *Old Stirling Clockmakers*, who serves the city by maintaining the Smith clocks.

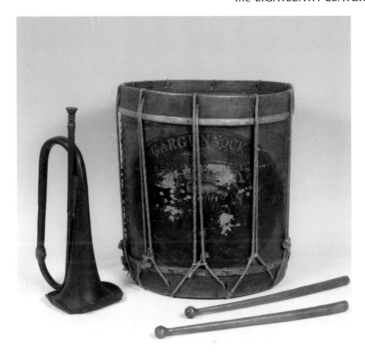

Gargunnock trumpet and drum.

THE TRUMPET AND drum date to 1775, and are the historic symbols of the village of Gargunnock. They were bought with the profits of the annual horse race, following the decision of a public meeting to appoint a drummer to announce the hours at 5 a.m. and 9 p.m. The drum was for dry days and the trumpet for wet ones. The reason for this was the lack of public clocks in the village. The drummer also went round in the spring, giving notice to people to have their poultry closed in when the villagers started work in their gardens.

The drummer was paid annually by public subscription on Auld Hansel Monday (Auld Hansel Monday being the first Monday after 11 January). Many people in Scotland added on the 'eleven lost days' cut from the calendar in 1752, and celebrated the New Year on Auld Hansel Monday when visits were made and gifts exchanged. Today, the Sons of the Rock in Stirling still maintain the tradition.

The trumpet and drum are well known in Gargunnock, where they appear on the masthead of the popular quarterly Gargunnock News. In reality, they can be seen in the Stirling Smith.

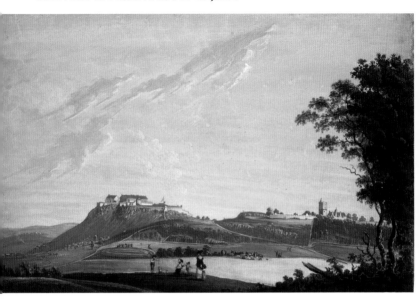

Stirling from the south. (Watercolour, Adam Callander, c. 1790)

SHOWN HERE IS one of a pair of early watercolours in the Stirling Smith collections by artist Adam Callander, who was active from 1780-1811, when he exhibited a total of fifty-one paintings at the Royal Academy in London. Before the Royal Scottish Academy was established in Edinburgh in 1826, many Scottish artists had to go to London to get exhibition space and a market for their art. Callander also travelled widely, painting in South Africa, Tenerife, and the Mediterranean.

This view of Stirling from the south shows the Kings Park area before any of the Victorian development took place. Kings Park was the pleasure and hunting grounds of the Stewart monarchs when staying in Stirling Castle.

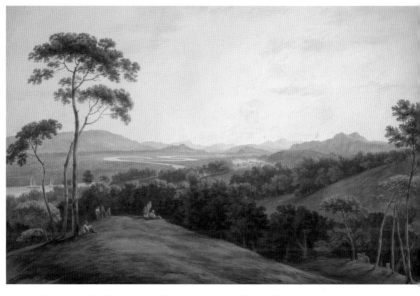

A distant view of Stirling, c. 1790. (Watercolour by John Warwick Smith)

THIS SUNSET WATERCOLOUR shows Stirling in the middle distance with the windings of the River Forth like a silver ribbon on the landscape. The town of Alloa can be seen centre right with the Ochil Hills, and in the distance, the wilds of the Trossachs.

The view was painted by the English watercolour artist, John Warwick Smith (1749-1831), whose works have always been greatly valued. It was originally commissioned by the fourth Duke of Atholl as part of a collection of fifty-six drawings. Smith was one of the founding members of the Old Watercolour Society and this sketch is an early example of the medium. Smith's best works are his sketches on the spot and many were influenced by Francis Towne (1740-1816), who travelled with him to Italy on a study tour under the patronage of Lord Warwick. This painting illustrates Smith's preferences for blues and greens and his characteristically strong contrasts of light and shadow.

The work was secured for the Stirling Smith at auction recently, thanks to a grant from the National Fund for Acquisitions, administered with government money by the National Museums of Scotland, the Art Fund, and funding from the Friends of the Smith.

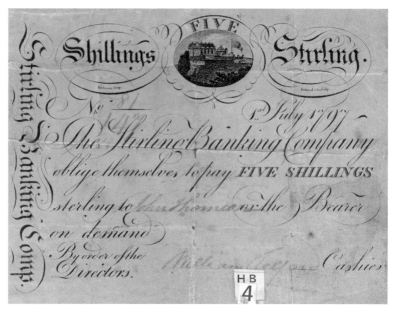

Five Shillings Stirling.

FOR OLDER PEOPLE, the brown ten shilling note which was removed from circulation in 1969 is a pleasant and nostalgic memory. The five shilling note, which was used in the eighteenth and early nineteenth centuries, is now beyond all living memory.

The Stirling Smith Art Gallery and Museum has several five shilling notes, and the example shown here, issued by the Stirling Banking Co., is for five shillings Stirling. Dated 1 July 1797, it is signed by William Telford, the cashier of the bank.

The Stirling Banking Company was founded in 1777 by seven partners. It occupied the building on the corner of Broad Street and St Mary's Wynd (long since demolished) where Keith McDowall's Broad Street Stores now are, and was known as 'The Corner Bank'. It had a branch in Alloa and another in Falkirk, before it ceased trading in 1826.

Stirling was also home to the Stirling Merchant Bank Company, 1784-1814, known by the Edinburgh financiers as 'The Black in the West' because of its poor performance. Both banks ended in litigation and financial disaster due to the poor economic situation and foreign wars 200 years ago.

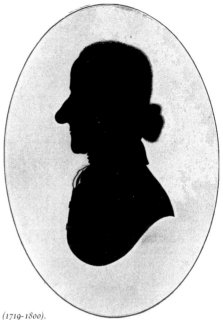

Silhouette portrait of Dr David Doig (1719-1800).

RECTOR OF THE Grammar School in Stirling, Dr David Doig was one of the people who entertained the poet Robert Burns during his visits to Stirling in 1787. Although Burns described him as 'something of a pedant', Doig was one of the most intelligent and hardest working public servants that Stirling has ever had. He was appointed to the Grammar School at the age of forty-one and died, in the job, at the age of eighty-one in 1800.

Doig was a great scholar with a talent for languages. He was also well versed in Scottish poetry, and wrote works of his own. He corresponded with some of the most eminent people of the times, including Lord Kames, the improving laird of the Blairdrummond Estate, and with John Callendar of Craigforth on matters of poetry. He even contributed articles to the Encyclopaedia Britannica on the subjects of Mythology and Philology.

The home territory of the world-wide Doig family is the parish of Kilmadock, Doune. They take their name from the celtic saint, Cadoc, whose day is celebrated on 24 January.

Robert Burns. (Oil on canvas, artist unknown)

THE CANVAS INDICATES that the portrait was probably done for the centenary celebrations of Burns' birthday in 1859.

Robert Burns (1759-1796) visited Stirling in August 1787, on his Highland tour. He came to see the sights and spent time in the company of Dr David Doig, Master of the Grammar School, and others. He was mobbed in Broad Street, like a rock star. He was saddened by the poor state of Stirling and scratched his poem, Stirling Lines on a window in Wingate's Inn (now the Golden Lion Hotel). He later had to break them to avoid prosecution. The thoughts expressed were pro-Jacobite and treasonable.

On 12 March 2002, the day that Stirling became a City, the lines were cut in slate at the entrance to the Stirling Smith:

The Stirling Lines

Here Stewarts once in glory reign'd,
And laws for Scotland's weal ordain'd;
But now unroofed their palace stands,
Their sceptre fallen to other hands;
Fallen indeed, and to the earth,
Whence grovelling reptiles takes their birth;
The injured Stewart line is gone.
A race outlandish fills their throne;
An idiot race, to honour lost –
Who knows them best, despise them most.

John Anderson, My Jo. (Oil on canvas by William Kidd)

John Anderson, my jo, John
When we were first acquent
Your locks were like the raven
Your bonny brow was brent

But now your brow is bald, John
Your locks are like the snaw
But blessings on your frosty pow
ohn Anderson, my jo.

THIS BEAUTIFUL TWO-VERSE love song is a favourite performance
piece at Burns Suppers all over the world. The theme is life-long love
from youth into old age. As with many songs of our national poet
Robert Burns, this is written from the female perspective.

The artist William Kidd (1796-1863) frequently illustrated the
works of Burns, and this picture in the Smith's collection shows John
Anderson, possibly the victim of a stroke, being cared for by his wife.
In the distance on the left are a young man and woman with a baby
and toddler, perhaps representing John Anderson and his family at an
earlier stage in life.

This is one of several works illustrating Burns in the Stirling collection.

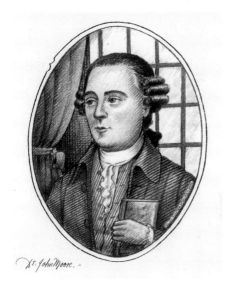

*Tinted drawing, Dr John Moore
(1792-1802) by Colin H. McQueen..*

STIRLING HAS MANY important associations for the life and work of Scotland's national poet, Robert Burns. We have a significant autobiography of the poet, written in the form of a long letter to Dr John Moore. Moore was a 'Son of the Rock', born in Stirling to the Reverend Charles Moore, Minister of the second charge in Holy Rude, and his wife Marion Anderson.

Moore served as an army surgeon in the Netherlands before setting up a medical practice in London. He was also a writer, and published a best-selling novel *Zeluco*. He made contact with Burns after receiving a copy of the poet's Kilmarnock Edition from a mutual friend, Anna Wallace Dunlop. It was her descendant, Marion Wallace Dunlop, who took her inspiration from William Wallace, in her fight for the cause of universal suffrage in the early twentieth century.

Burns poured out his life story to Dr John Moore in July 1787. That precious manuscript letter is in the care of the British Library. The Moore portrait shown here is by author and Burnsian, Colin Hunter McQueen.

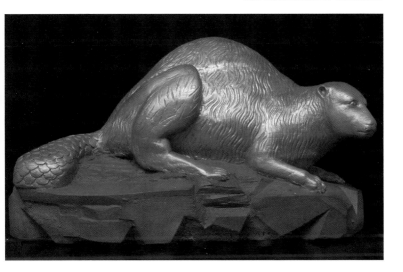

Carved wooden shop sign, c. 1800.

IN THE EIGHTEENTH century, the word 'beaver' and 'hat' were virtually synonymous. Beavers were hunted to extinction in Scotland in the 1600s, and so beaver skins were imported from Scandinavia and later from the American colonies to supply the hatters' trade. Robert Burns' song, Cock up your Beaver, is about a young man improving himself with the purchase of a beaver hat.

This shop sign was made for a hatter's shop at No. 3 King Street by a carver who probably had never seen a living beaver, but had produced a shape with tail attached, from seeing a skin or a book illustration.

Stirling had four hatters' premises in the nineteenth century. The trade was not a healthy one. Use of arsenic and other chemicals in dressing the fur resulted in damage to the central nervous system, which often displayed itself in the form of tics and involuntary muscle movements. This gave rise to the common saying 'As mad as a hatter'.

The shop sign was rescued from a bonfire by property owner Peter Wordie in 1970. In 2009, beavers were re-introduced to Scotland from Scandinavia, at the same time as this shop sign was presented, by the Friends of the Smith, with a Mad Hatter's Beaver Party.

William Murdoch's Model Steam Carriage, c. 1790.

A MODEL STEAM carriage, an experimental model with early square condensing chamber, (*c.*1790), made by William Murdoch (1754-1839), inventor of gas lighting and many improvements to the steam engine.

This is possibly one of the rarest treasures in the Smith collections. Found in the attic of a house in King's Park, it was presumed to be a toy and was gifted to the Smith in 1961. It was recently recognised as a table model of a steam carriage, built for demonstration purposes, and identified as the work of the famous Scots inventor.

From time to time, objects in the Smith's collections are reassessed when new information comes to light. As Ivor Corkell of the William Murdoch Society writes:

> It is highly likely that Murdoch took his third model engine back to Scotland when he finally left Redruth in 1799 and it is this engine that should have been the model for our road engine. Your engine is very important as it gives an insight into what was probably the World's first successful locomotive. Murdoch would have been unable to take his large road engine back to Scotland with him and so your engine should be preserved as probably the only real example of the birth of the steam locomotive. Certainly there are no preserved Cugnot or Trevithick road engines.

five THE NINETEENTH CENTURY

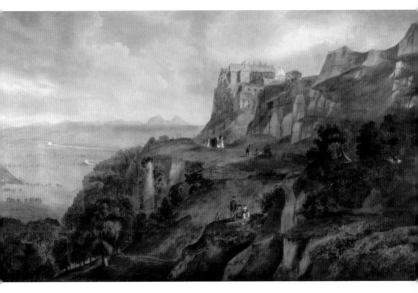

Stirling Castle, c. 1820. (Watercolour, artist unknown)

THERE ARE MANY hundreds of views of Stirling Castle; because it was an important military stronghold until the 1960s, trees and bushes were not allowed to grow on the escarpment. The Back Walk and the routes to the castle were kept bare, for reasons of security, as shown in this anonymous watercolour of the 1820s.

From the 1830s, any wood growing there was eagerly harvested by the souvenir wood workers of Mauchline, and thousands of tourist trinkets and keepsakes, from boxes to book covers, were inscribed as 'Made from the wood grown on the slopes of Stirling Castle'.

The Stirling landscape with the three great escarpments of the Castle Rock, Abbey Craig and Craigforth, and the spectacular windings of the Forth below, was a magnet for artists as well as tourists. Every landscape artist of note knew of the beauty and importance of Stirling, and yearned to paint it.

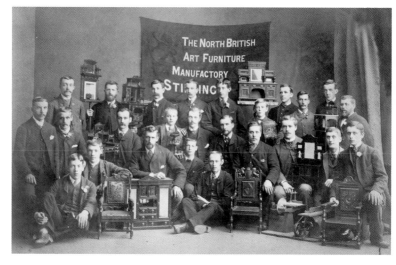

Employees of the North British Art Furniture Manufactory, 1887.

THERE IS A rich heritage and history of furniture manufacturing in Stirling. The industry still continues in the form of the great furniture warehouse of Sterling at nearby Tillicoultry. The Smith still receives regular enquiries on the furniture made by older factories.

This photograph shows the employees of the North British Art Furniture Manufactory on 24 June 1887, prior to their march in procession to the National Wallace Monument for the unveiling of the Wallace statue by D. W. Stevenson. It was a proud civic occasion, involving most of the public organisations in the burgh.

The Manufactory was situated in Forth Street, and only closed when its owner, J. W. Small, moved to South Africa in 1904. It was one of several local firms to take part in the procession. Each man made a piece of model furniture, and carried it on a pole in the procession for the appreciation of the crowds. Two of the model pieces in the photograph are in the collections of the Stirling Smith.

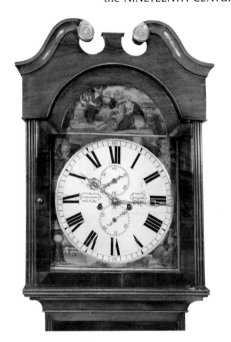

Canadian cradle clock.

THIS CLOCK IS a gift to the Smith by Isabelle Mitchell Powell of Oxford. A long case clock by Williamson of Falkirk, it was owned by the Mitchell family who farmed in the Plean area, to the east of Stirling. In the early nineteenth century, they emigrated to Canada from Greenock. The night before they were due to leave, they left their baby daughter with relatives in Greenock whilst they settled on to the ship with their trunks and the clock. A wind arose during the night and so the Captain took advantage of it and sailed. The family did not see their daughter for eighteen years. In today's world of global and instant communication, we forget the pain of separation endured by previous generations through emigration.

During its lifetime, the clock was dragged by sledge as the family moved across Canada. The case of the clock also served as a cradle for later children when the family were on the move. It came back to Britain in the twentieth century.

Charles Allan, clock specialist and author of *Old Stirling Clockmakers*, undid the damage of the past two centuries and restored the clock to full working order. The conservation work was funded by the Friends of the Smith.

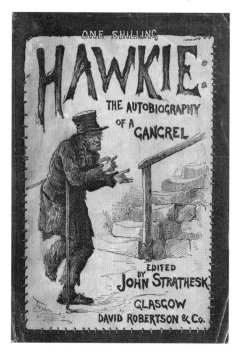

'Hawkie', from Plean.

WILLIAM CAMERON, ALIAS 'Hawkie', was one of the best-known chapmen and ballad-criers in Scotland, and although he died in 1851, he is still remembered as one of the wittiest and most clever of the so-called 'Glasgow Characters'. Before he died in the Glasgow poorhouse, arrangements were made for the publication of his autobiography. The Britannia Pottery in Glasgow also produced little earthenware figures of him, and his story was featured in publications and even in the waxworks.

Hawkie was born into a family of farm labourers in the Stirlingshire village of Plean. As a small child, he was severely crippled by farm machinery when the six year old caring for him neglected his safety. He grew up unfit for farming work, but was extremely intelligent.

Hawkie made his way of life as a ballad-crier and storyteller. He excelled at gathering a crowd in the street and selling his ballads for a penny a time. His autobiography gives a colourful insight into the conditions of the poor in Victorian Scotland, and is also a work of significant literary merit of which the people of Plean and Scotland can be proud.

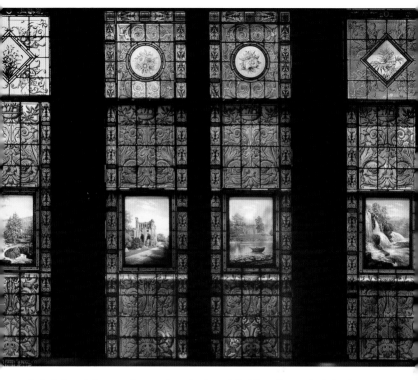

Stained glass window, 1880, incorporating painted panels by Messrs Cooper of Edinburgh, 1837, celebrating the life of Sir Walter Scott.

THE STAINED GLASS window in the Smith lecture theatre was formerly the staircase window of Springbank House, built around 1880 and demolished in the early 1970s to make way for the building of Central Regional Council's headquarters. Rescued by Stirling Archives, it celebrates the life of Sir Walter Scott, whose works turned Stirling and the Trossachs into a major tourist destination. His poem, The Lady of the Lake (1810), set in the area between Loch Katrine and Stirling Castle, contains two airs which are still known worldwide: 'Ave Maria', composed by Schubert, and 'Hail to the Chief', which is played for every American President.

The window features Abbotsford, the house which Scott built in the Borders, Dryburgh Abbey (his burial place) and 'the land of the mountain and the flood'. The painted panels were exhibited by Coopers of Edinburgh in 1837 and were built into the window about forty years later.

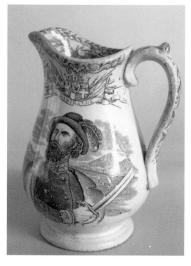

Giuseppe Garibaldi – 'the Wallace of Italy'. (Reverse painting on glass)

GIUSEPPE GARIBALDI (1807-1882) was popularly known as 'the Wallace of Italy'. A great soldier, wresting Italy from foreign domination and its unification, was his life's purpose. He was as popular, and as internationally in demand, in the 1860s as Nelson Mandela was in the 1990s. Scotland sent a large number of recruits to fight with Garibaldi's Red Shirts in his various campaigns, and significant sums of money were raised here to aid him. The Stirling Smith has several portraits of Garibaldi, including one painted on glass and another on a Glasgow-made jug.

When fund-raising for the National Wallace Monument in the 1860s was difficult, Garibaldi and his countryman Giuseppe Mazzini, the founder of the Young Italy movement, were asked to write letters in praise of Wallace to support the Monument. These were framed in the Wallace Oak of Elderslie, and are now in the Stirling Smith collections.

Stirling was so keen on Garibaldi that there was a much-reported urban legend claiming that his father was a Stirling man, one Bauldy Garrow, son of a shoemaker at the Old Bridge of Stirling, who enlisted in the 42nd Regiment and married an Italian girl. There was a Garibaldi Coal Pit in Skinflats, and Joe Trenaman (1911-1962), who is remembered by a seat in Ailie's Garden in the Smith grounds, had Mazzini as his middle name, such was the popularity of these Italian heroes in Scotland and in Stirling. Even today, the Garibaldi biscuit, made from the flour and raisins which nourished his army, is still very popular.

Executioner's cloak and axe, 1820.

THE PUBLIC EXECUTION of John Baird and Andrew Hardie, in Broad Street on 8 September 1820, was one of the bloodiest and most unjust episodes in Stirling's history. A group of radical weavers, who rose against the government, were captured at Bonnymuir, and imprisoned in Stirling and Edinburgh Castles.

Twenty of them were sentenced to transportation to Australia. Baird and Hardie were found guilty of High Treason, and given the same sentence as William Wallace in 1305:

> drawn on a hurdle to the place of execution,
> and there hung by the neck until you
> are dead, and afterwards, your head
> be severed from your body, and
> your body divided into four
> quarters to be disposed of as
> His Majesty may direct.

A third man, James Wilson, was similarly executed in Glasgow.

As the Stirling hangman refused to cut off the heads of the accused, a young medical student from Glasgow, Thomas Moore, was hired to do the job. The cloak and axe used by him are in the Stirling Smith collections. Baird and Hardie are regarded as martyrs and founders of our modern democracy and, for that reason, the Smith also has a desk and chair from the Scottish Parliament of 1999, where visitors can read up on this seminal moment from Stirling's history.

Stirling Worthies, c. 1880. *(Oil on canvas by R. Ramsay Russell)*

THIS PAINTING SHOWS the Stirling characters in King Street with the Corn Exchange in the background and the Golden Lion Hotel on the right-hand side. From left to right, the Worthies are:

1. 'Humphy Geordie' – George Sutherland, a weaver from the top of the town, who also sold sheep heads and pig trotters from the flesh market.
2. Blind Tom. Irish by birth, he had the ability to recognise people by their voices. He was a flute player.
3. 'Stulty Andrew' – Andrew Wilson from Falkirk had a wooden leg, hence the nickname. He sold chapbooks and songs in the streets.
4. 'Bumming Jamie' or 'Jamie the Bee', the odd-job and delivery man was so called because he hummed when he walked.
5. 'Praying Pete'.
6. Tommy Chalmers the Stirling Bellman. A number of people contributed to the purchase of his blue uniform, of which he was proud.
7. 'Wee Towan' was small, with a speech impediment. His wearing of the Scottish blue bonnet, fashionable in the eighteenth century, made him a well-known figure in the town.

Note the D & J MacEwen label on the barrow. MacEwen were quality grocers in Stirling for almost 200 years. Now a property company, MacEwens celebrated their bicentenary in 2004.

The Pipe of Freedom. (Oil on canvas by Thomas Stuart Smith)

THE BEQUEST OF the artist Thomas Stuart Smith (1814-1869) and his collection of paintings was the foundation of the Smith Institute, now the Stirling Smith Art Gallery and Museum, in 1874. The Royal Burgh of Stirling provided the site, and Smith provided the money and the collection.

The Pipe of Freedom, which celebrates the abolition of slavery in America, is his best-known painting. At the time it was controversial, for the Royal Academy in London refused to hang it on account of the subject. Behind the pipe smoker is an abolition poster, pasted across a notice for the sale of slaves. His red shawl has attracted the attention of costume historians, who believe that it could be of Paisley origin. With the interest in Black History, the painting has been loaned to many other museums.

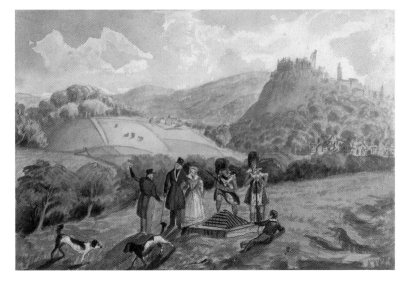

The Borestone, 10 May 1842.

THE ARTIST WILLIAM Greenlees has captioned his picture as follows:

> 'STIRLING CASTLE from the field of Bannockburn. The stone on
> which BRUCE'S standard was placed. May 10 1842.'

Greenlees was a well-known Edinburgh artist who exhibited regularly at the Royal Scottish Academy in the period 1847-1850.

By tradition, the large whinstone rock or Borestone was where King Robert the Bruce placed his flag on the eve of the Battle of Bannockburn, 22 June 1314.

The Borestone was sought out by generations of visitors to Stirling, and so many souvenirs were taken from it that the land owner encased it in a metal grille in 1836. Two Black Watch soldiers from the 42nd Regiment, in Stirling for the royal visit, and four others are shown inspecting it. A flagpole was added in 1870 to assist visitors in finding the spot.

In 1957, the Borestone was eliminated by the cairn built by Stirling Guildry, a loss which is mourned in Lesley Duncan's poem, Careless with Stones.

'The Signal'. (Oil on canvas by John Phillip)

'THE SIGNAL' BY artist John Phillip RA (1817-1867) is one of the best-known paintings in the Smith's large collection of European and Scottish oils

Phillip, a native of Aberdeen, favoured painting Spanish subjects, and he is sometimes referred to as 'Spanish Phillip' and even 'Phillip of Spain'. This painting shows a shy Spanish lady leaning over her balcony with a camellia to give 'The Signal' to her lover below. The work was borrowed by the Alhambra Palace in Granada in 2009, as directly illustrative of the works of writer Washington Irving (1743-1859) who did much to shape the European consciousness of Spain.

'The Signal' was among the paintings of the foundation bequest of Thomas Stuart Smith. It was popularly known as 'Mrs Smith' as the painting went with him everywhere on his travels. Smith never married, and left all of his fortune and his paintings for the construction of an art gallery 'for the benefit of the people of Stirling, Dunblane and Kinbuck'.

Craigmill House. (Watercolour by Joseph Denovan Adam)

STIRLING IS FAMED for the beauty of her landscape, which has been an attraction to artists for generations. The scene in this lovely summer watercolour of Craigmill House on the A907 between Causewayhead and Alloa has not changed a great deal in the intervening years. Craigmill House still stands, and the structure in the field opposite, where the artist Joseph Denovan Adam ran his summer schools (1887-1895) in the art of painting animals, has been rebuilt.

The scene shows curious Highland calves looking at an abandoned parasol and shawl. Adam kept a fold of Highland cattle for his students to paint in this field, and painted them himself many times.

Some months after the purchase of this painting, another of the same scene was illustrated on the website of an American gallery. The painting featured a pretty young woman reading a book, with the calves in the distance. The artist had painted a 'before' and 'after' scene. The 'before' watercolour was valued at many times the price of the Smith's painting, as Adam is highly renowned in the USA.

The Herd's Hoose. (Oil on canvas by Leonard Baker)

THIS PICTURESQUE SHEPHERD'S cottage, known locally as 'the Herd's Hoose' was a feature of the old King's Park, prior to its demolition in the early 1860s. Nearby was a well, visited for its healing properties, known as Patie's (Peter's) Well. Also shown in the painting is a large glacial boulder known as 'the Rocking Stone'. The third hole of the King's Park Golf Course is now sited near this feature.

This painting in the Smith's collection is by artist Leonard Baker (1831-1911). Baker trained at the London School of Design, moved to Dunfermline in 1854 to instruct designers in the linen trade, and came to Stirling in 1857 as a drawing master for the High School. When the Smith Institute opened in 1874, he worked with the curator to set up the first art exhibitions, and helped establish the Stirling Fine Art Association in 1882.

When the High School of Stirling was rebuilt in 1887-9, the facilities for the study of art were greatly enlarged. On account of Baker's enthusiasm, commitment and dedication, it was said 'the art classes of the High School of Stirling have long been recognised by competent authorities as unsurpassed by any similar classes in the country.' He inspired a generation of local artists.

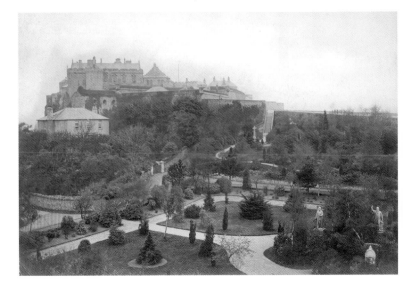

The Valley Cemetery.

DURING ONE OF his Scottish tours, William Wordsworth wrote that 'We know of no sweeter cemetery than that of Stirling'. The Valley Cemetery was part of a great landscape improvement scheme in the 1850s. 'The Valley' was a very rough area used by the horse market, the travelling shows and tinkers' camps. Going to 'see the fules in the Valley' was a Stirling pastime in the eighteenth and early nineteenth centuries. The Reverend Charles Rogers, who campaigned for the building of the Wallace Monument, working with Seed Merchant William Drummond (1793-1868) who funded the project, created a beautifully landscaped burial ground, which was also, through its seven statues, a teaching ground for the history of the Scottish Church, 1560-1850.

The gardening manual which they used was Isaiah Chapter 40: 'Prepare ye the way of the Lord, make straight in the desert a highway for our God. Every valley shall be exalted … the crooked shall be made straight and the rough places plain.'

William Blake sang about building Jerusalem in England's green and pleasant land, but Drummond built it in Stirling – and it is still there for all to enjoy, free of charge.

Right: *Star of Snowdon Purity Brooch. (Enamels, 1859)* Far right: *Virgin Martyrs. (Souvenir paperweight, 1860s)*

SNOWDON IS THE ancient and poetic name for Stirling, and the Star of Snowdon Purity Brooch is a special, commemorative piece of Stirling jewellery.

Several of these brooches were made for the female members of the Drummond family to mark the inauguration of the Virgin Martyrs' memorial in the Valley Cemetery in 1859. The Drummonds, who were seedsmen and agricultural suppliers, sponsored the development of the showground between the castle and the Holy Rude burial ground as a modern and instructive cemetery in the late 1850s. The cemetery was adorned with statues of the heroes of the Protestant Reformation.

Cut in white marble, The Virgin Martyrs was the only statue of a grouping of women. It commemorated the martyrdom of the Covenanters Margaret Wilson and Margaret McLaughlan, who were sentenced to death by drowning in the tidal waters of the Solway, 11 May 1685. Agnes Wilson, Margaret's young sister, was excused on account of her age. The three women are represented by the forget-me-nots and the cross, crown and laurel leaves of martyrdom. The pearl of purity, centred in the star, is also symbolic of the name Margaret, the Christian name of the martyrs.

The Virgin Martyrs grouping was sculpted by Alexander Handyside Ritchie (1804-1870), who exhibited the work in his Edinburgh studio before the installation in Stirling in 1859.

The souvenir paperweight was probably made in the Alloa Glass Works, at some time before the protective canopy was erected over the group in the early 1860s.

The Valley Cemetery received a Lottery-funded makeover in 2008-9 and remains a popular Stirling visitor attraction.

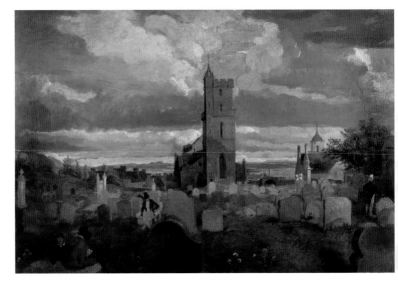

The Old Kirkyard, 1835. (Oil on canvas by Robert Mitchell)

THIS WORK SHOWS the burial ground at the back of the Church of the Holy Rude at the top of the town. The Watchman's Hut on the right, beside the trees, was a temporary necessity on account of the grave robbers of the 1830s. The tower of Cowane's Hospital can be seen beyond. To the left of the church are the roofs of Broad Street. A gravedigger and his family are in the left foreground.

The painting was by Robert Mitchell (1803-1845), and a letter by his son in 1877 describes how the artist, with the assistance of his apprentices, erected a platform in the kirkyard to achieve his desired viewpoint.

Mitchell was a professionally trained artist, and possibly a pupil of Glasgow teacher John Knox. He worked in the Stirling area as a house painter and was a member of the Guild of Mechanics. He served as a Councillor in the 1840s and was involved in the restoration of the Mercat Cross in Broad Street. Fittingly, his final resting place is not far from the viewpoint of this painting.

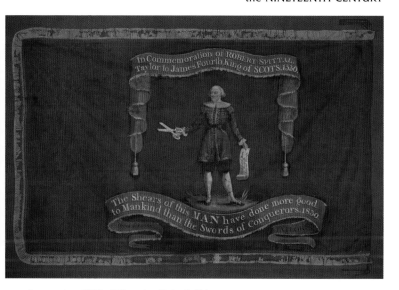

Incorporation of Tailors' Flag, 1830. (Painted silk)

THE FLAG OF the Incorporation of Tailors is truly one of the treasures of the Stirling Smith. Commissioned in 1830 to commemorate the 300th anniversary of the foundation of Spittal's Hospital, it is painted on silk and is only shown for short periods of time, for reasons of conservation. It was painted by Robert Mitchell (1803-1845), an artist who made his living as a house-painter and lived at No. 17 King Street. His painting of the Old Kirkyard is also in the Smith's collection.

The central feature of the flag is Robert Spittal (c.1480-1558), tailor to King James IV and his queen, Margaret Tudor. Spittal, like many court tailors, was wealthy and left money for the foundation of a hospital or almshouse.

Spittal Street is named after him, and he has always been honoured in Stirling. The flag proclaims that 'The Shears of this MAN have done more good to Mankind than the Swords of Conquerors'. Note the banner in Spittal's hand: 'The Liberal Man desireth Liberal Things.' This flag would be carried in the Reform Bill processions in the 1830s, when working people were petitioning for the right to vote. The Liberal Party at that time were the party in favour of parliamentary reform.

The Bow, Stirling. (Watercolour by Jane Ann Wright (1842-1922))

THE BOW (NOW Bow Street) was the dangerously sharp bend connecting Broad Street to Baker Street at the top of the town. Before the road engineers worked to make it safe in the twentieth century, it was notorious for causing difficulty to horses and vehicles. It was also a picturesque feature of the old town, and attractive to artists. Pictured here is a watercolour of The Bow by Jane Ann Wright in the 1890s.

The Bow featured in a children's song in the early nineteenth century: 'Hey cockie doodle, hey cockie doo / Did you see the Grand Duke, coming down the Bow?' The Duke was a Prussian Prince who visited Stirling. Queen Victoria's plans to visit Stirling Castle in 1842 gave cause for concern, because of the difficulty of steering a carriage with four horses round the Bow. William Ramsay (1809-1850) MP, noted horseman and promoter of the Stirling Races, was the man chosen to drive the carriage and, although he was practised and experienced, the cheering and firing of the crowds caused trouble for the horses. It was said that the Queen had 'tears of fright' in her eyes on the road to, and from, the castle.

This watercolour is one of a series of ninety-three by Wright, all of great topographical interest to Stirling and Stirlingshire, in the Smith's collections.

Black Beast Wanderer. (Oil on canvas by Joseph Denovan Adam)

THIS PAINTING OF a black Highland cow in the depth of a Scottish winter is one of the masterpieces produced by the animal artist Joseph Denovan Adam (1841-1896) who worked at Craigmill, Stirling. Although small, it is also one of the treasures of the Smith collection.

Black cattle were the traditional native breed of Scotland. Small and sturdy, they were sure-footed and could survive on the sparse grazing in the Highlands of Scotland. They are able to survive intense winters, and in Scandinavia are the only breed permitted to be kept outdoors for the entire duration of the winter.

In the eighteenth century, the black cattle were one of the main economic resources of Scotland. Every autumn, they were taken by Highland drovers on foot south to the cattle trysts of Doune, Stirling and Stenhousemuir, to be sold on and fattened for the English markets.

The word 'blackmail' originates with this trade, 'mail' being the Scottish term for rent. Individuals like Rob Roy MacGregor regularly took cattle belonging to others, but returned them on receipt of a mail or rental, for having 'taken care' of the beasts.

In Victorian times, stock breeders produced Highland cattle in the more fashionable brown and red colours, beloved by artists like Adam.

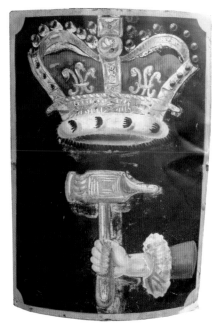

The Hammermen. (Painted tinplate emblem, c. 1830)

THE HAMMERMEN WERE the first of the Seven Incorporated Trades of Stirling, the others being the Weavers, Tailors, Shoemakers, Fleshers, Skinners and Bakers. In most towns, the Hammermen considered themselves to be the most significant of the trades, as their motto suggests, 'By hammer in hand all arts do stand.'

The Hammermen included all who wielded the hammer. All of Stirling's seven trades had their origins in the Royal Court – the most important of these being the gold and silversmiths. The dependence on horses made the blacksmiths or farriers fairly significant also. Clock-makers, lorimers (harness makers), pistol makers, sword smiths, pewterers and jewellers were also part of the Hammermen's trade guild in Stirling.

The insignia of the Hammermen was a crowned hammer, as shown on this eighteenth-century tinplate processional emblem in the collections of the Stirling Smith. The Smith also has the Hammermen's Flag of 1830. The patron saint of the Hammermen was the legendary St Eloi or Loy, the sixth-century French bishop who made a golden throne for King Clovis. The Church of the Holy Rude had an altar dedicated to St Eloi, financed by the Hammermen guild.

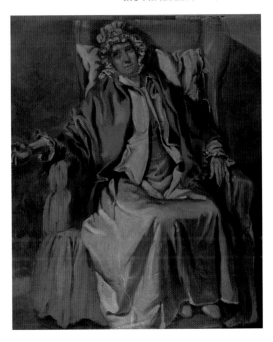

Woman having her pulse taken. (Oil on board by Sir George Harvey)

PAINTINGS DEPICTING ILLNESS are quite unusual, and the Smith is fortunate to have several. This oil sketch by Sir George Harvey (1806-1876) shows a woman having her pulse taken. Harvey was the son of a St Ninian's clock-maker. The Smith has seventy-eight of his preparatory sketches, rescued by his niece and presented to the museum in 1935.

Harvey painted many everyday scenes like this in Stirling, in preparation for his larger paintings on canvas. The collection of sketches of oils on paper in the Smith is really a portrait gallery of Stirling people in the nineteenth century, in the decades before photography was invented. People were captured in Harvey's quick sketches doing ordinary things – a nurse warming a garment, a boy playing with his dog, a family waiting for a judgement at the law courts, and even a school teacher administering 'the belt'.

Harvey also received commissions to do formal portraits of people in Stirling, and the Smith has examples of those too. Harvey became the fourth President of the Royal Scottish Academy, and his best-known paintings hang in other galleries in Britain. The Smith is very fortunate to have these lively sketches of the ordinary people of Stirling.

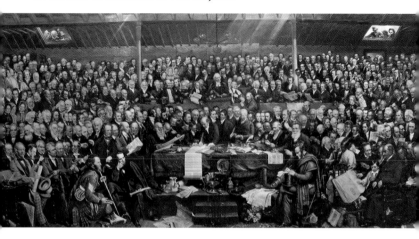

The signing of the Act of Separation and Deed of Demission, 1843.

THIS IS A former treasure of Chalmers Church, Bridge of Allan (1844-2003) and it records one of the most momentous events in Scottish history. On 23 May 1843, a third of the ministers of the Church of Scotland walked out of their manses and gave up their churches to maintain their spiritual independence, and the Free Church of Scotland was born. The split was over patronage – the right of the congregation to choose the minister, against the wishes of the local land owner. In Bridge of Allan, most of the congregation left Lecropt Church to meet in a joiner's shop as the Church of Scotland Free.

The photograph is of a painting by D.O. Hill and his wife Amelia Paton on the signing of the Act of Separation and Deed of Demission. The declaration was signed by 386 ministers in the presence of 3,000 others 'who hung in silence over the scene'. Subsequent signatures brought the total to 474.

Full use of the new art of photography was made by D.O. Hill to record the subjects in the picture prior to painting. When the work was completed, every Free Church placed an order for a photograph of this momentous work.

Spirit of Reform flask, 1832. (Prestonpans Pottery)

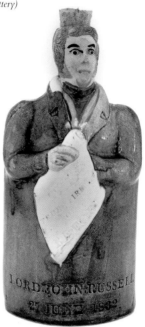

THIS LITTLE CERAMIC whisky flask, in the likeness of the politician Lord John Russell (1792-1878), is inscribed 'the Spirit of Reform' and marked with the date 27 June 1832, the day on which the Reform Bill was passed.

When the news of the Bill reached Stirling, the magistrates ordered the bells to be rung and the town to be illuminated. Shop windows were decorated to celebrate the passing of the Bill, which gave some men with property the right to vote. Further bills extending the franchise were passed in 1867 and in 1884, but only after fifty years of demonstrations and political agitation.

Women fought even harder for the right to vote. After a further fifty years of polite petitioning proved to be of no use, they took their fight to the streets, and many suffered imprisonment. In 1918, women aged thirty and men aged twenty-one and over, were given the franchise. The Representation of the People Act, 1928, gave women the vote on the same terms as that of men.

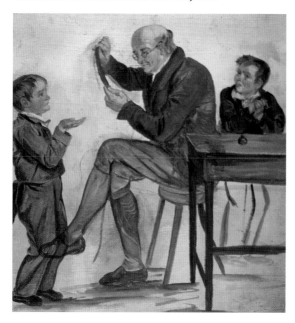

Getting the Belt.
(Oil on board by
Sir George Harvey)

THE SCENE DEPICTED here by Stirling's Sir George Harvey (1806-1876) in about 1840, is one known to anyone who went to school in Scotland before 1980. Teachers kept discipline in the classroom by administering 'the belt', a leather strap or tawse, to the hands of the offender. In the sketch, the boy on the right is nursing his hands whilst sticking out his tongue to the teacher, who is strapping another pupil. This scene took place on a daily basis in classrooms for at least two centuries – but George Harvey is probably the only artist who ever depicted it so vividly.

The belt was also commonly known as the Lochgelly, after the Fife town where the straps were manufactured by saddler John G. Dick, in weights of Light, Medium, Heavy and Extra Heavy, priced from 15s to 16s and sixpence in 1966. Most teachers used belts manufactured in Lochgelly.

There were reputedly sixty strap makers in Scotland in the 1960s. One of these was D. W. Sutherland of Dunblane, and the Smith has acquired an example of his work for the collections. Straps were traditionally made by saddlers.

Use of the belt was stopped after a European Court of Human Rights judgement in 1982. Thankfully it was banned altogether in 1987.

Law agents and clients. (Oil on board Sir George Harvey, 1826-7)

SOLICITORS FIRMS ARE often the repository for the history of any town, as they retain title deeds and other historical documents in their offices. The oil sketch shown here is that of a law agent and his client by Sir George Harvey of Stirling, and dates to 1826-7. It is one of a number of quick sketches done for a large painting called The Small Debt Court, exhibited in Edinburgh in 1827. Harvey was aged twenty-one at the time, and it is likely his sketches are of Stirling people.

There are four legal firms in Stirling today whose history can be traced back 200 years or longer. These are Hill & Robb, of Pitt Terrace, whose archives contain documents of the sixteenth century, Mathie MacLuckie of Dumbarton Road, Jardine Donaldson of Port Street and Muirhead Buchanan of Allan Park.

The story of the emergence and development of solicitors in Stirling has been summarised in a publication for the Smith, written by retired advocate, William C. Thom LLB.

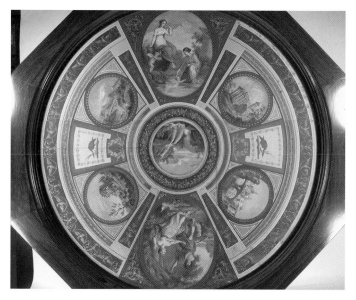

Bonnar's Box, c. 1820.

THIS WONDERFULLY DECORATIVE box, a gift to the Stirling Smith by a family descendant, is the work of William Bonnar RSA (1800-1853). The Bonnar family can trace their lineage to John Bonnar, master painter in Leith 1756, and there have been many talented artists in the family since.

In the eighteenth and nineteenth centuries, art, mural decoration and house painting were closely interlinked. The watercolour on the box lid is probably a miniature of a decorative painted scheme for a Victorian ceiling. By the mid-nineteenth century, the Edinburgh-based interior decoration firm of Bonnar & Carfrae was one of the best in Scotland, and, in 1874, they were responsible for the colourful interior of the newly-built Smith Institute. A member of the team, John A.T. Bonnar, took up residence in Stirling.

In the 1960s, the donor of this box, David Bonnar Thomson (1941-2007), was a frequent visitor to the Smith, sent by his art master James Atterson from the High School. David also made his name as an artist, but in the medium of film. The box represents an unbroken artistic thread which links the Smith Institute to a family of artists through generations over a 130-year span.

Purse of gold, 1853.

THE STIRLING SMITH has received several gifts of significance from other places in Britain. This 'purse of gold' is a gift from Mrs Peggy Keiser of Bristol, and is engraved with the following words: 'Presented along with Ten Sovereigns By a few Friends to Mr Wm Aitken on his leaving Cambusbarron for Ireland 1853.'

William Aitken was a smith who obtained the position of chief smith to the Earl of Longford. Blacksmiths' shops or smithies were busy places for the exchange of news and stories, and the smith's ability to shoe horses well and keep local transport moving was much appreciated. They also produced toys such as girds and cleiks, and repaired domestic metalwork.

The purse of gold was presented by farmers and others in the neighbourhood of Cambusbarron at a dinner on 5 May 1853. Needless to say, the contents have long been spent; to replace them at current prices would cost about £1,500, which is possibly close to the original spending power of the coins. Gold coins were commonly sewn into clothing, to prevent loss or theft – banks in the nineteenth century being as unreliable then as they are today.

National Wallace Monument. (Architect's drawing, 1859)

FOLLOWING DISPUTES BETWEEN Glasgow and Edinburgh, Stirling was chosen as the place for the National Wallace Monument in 1859. The site was the Abbey Craig, overlooking Cambuskenneth Abbey and Stirling Bridge, the place of Wallace's victory in 1297.

The architect who won the design competition was John T. Rochead (1814-1878), who built many fine Glasgow terraces, mansions, workers' housing, and churches throughout Scotland. He was also the favoured architect of the Free Church.

The foundation stone was laid in a great national ceremony on 24 June 1861, the stone being quarried from the Abbey Craig itself. Fund-raising and other difficulties meant that it took eight years to complete. It opened on 11 September 1869, the 572nd anniversary of the Battle of Stirling Bridge. Standing at 220ft high it has 246 stairs. The panoramic view from the top of the surrounding countryside and the windings of the River Forth brings thousands of visitors each year.

The Wallace Monument has always been a focal point for national causes. Suffragette Marion Wallace Dunlop (1865-1942) initiated the first hunger strike in 1909 when she was trying to emulate William Wallace in her own fight for Votes for Women. In 1912, suffragette Ethel Moorehead broke the case containing the Wallace Sword in the same cause. A 'Home Rule for Scotland' stamp, designed for marking the backs of English ten shilling notes in the 1930s, had the Wallace Monument as its symbol. The Wallace Sword itself was stolen by political protestors in 1936 and 1972.

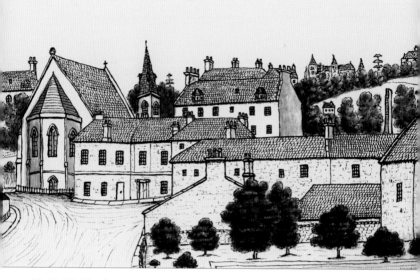

The English Chapel at Barnton Street, 1861. (Pen and ink drawing. Artist unknown)

THE ARTIST OF this tiny pen and ink drawing is unknown. It is signed as being 'My lodgings, English Chapel, East Stirling 22 July 1861'. The viewpoint is from Shore Road looking towards what is now Maxwell Place and Barnton Street, and it represents a part of Stirling which has changed greatly. As the main thoroughfare to the harbour and the industrial quarter, this would have been a busy part of town then, as now.

'The English Chapel', or Trinity Episcopal Church, was built on the triangular piece of ground on the corner of Barnton Street and Maxwell Place. It was demolished in the 1870s when the demand for shops in this part of town was pressing. The congregation then moved to their present church in Dumbarton Road.

Stirling in 1861 was a picturesque and well appointed place. The Valley Cemetery was laid out as a place of contemplation and education in 1857, and, in 1861, the laying of the foundation stone for the National Wallace Monument on Abbey Craig took place, to enhance Stirling as a tourist destination for generations to come.

The Stirling Qilin. (Dunmore Pottery, c. 1890)

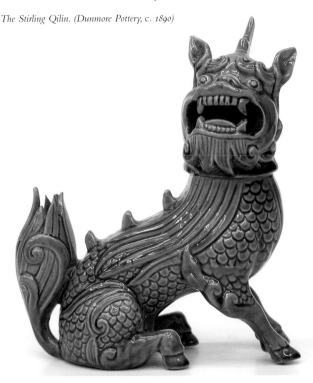

THE QILIN IS a wonderful beast from Chinese mythology. Indeed it is also known in Vietnam, Korea, Tibet, Mongolia and Japan. The Qilin has the body of a deer and the head of a dragon. Although it looks fierce, it is a most gentle animal, and will not harm even a blade of grass by walking on it. It therefore leaves no footprints, and can also walk on water. It can be fierce if a good person is threatened by an evil person, and will spout flames from its mouth.

The green-glazed pottery Qilin in the Stirling Smith collection is so beautifully made that it might be mistaken for a piece of Chinese ceramic. Nevertheless, it is clearly stamped 'Dunmore', indicating that it comes from the Dunmore Pottery works of Peter Gardner (1836-1902) near Airth, Stirlingshire. Dunmore Pottery was patronised by Queen Victoria, and the Prince of Wales was a frequent visitor to the Dunmore Estate.

Gardner, like many other Stirlingshire artists, sought his inspiration world-wide and Dunmore ware is now highly prized by collectors.

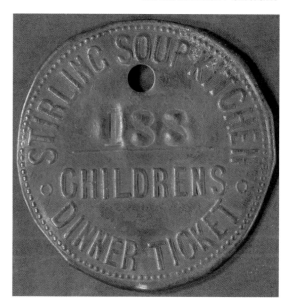

Stirling soup kitchen dinner ticket.

HISTORICALLY, STIRLING WAS famed for its charities. Cowane's and Allan's legacies or mortifications were left for the poor gild brothers or merchants of the burgh, and for educational purposes respectively. Robert Spittal's legacy supported poor tradesmen. Reports in the eighteenth and early nineteenth centuries claim that Stirling was so well endowed with charities, that it attracted beggars and poor people from other areas of Scotland.

In the nineteenth and twentieth centuries, soup kitchens were often set up in times of crisis, and were a feature of the miners' strikes of 1926 and 1984-5, as well as the army charities of the two world wars. This token for a Stirling soup kitchen was found among the papers of the Reverend James Paisley Lang of Stirling and probably dates from the late 1890s.

Drummond tract, 1860.

THIS BOOKLET IS a rare relic of Stirling's printing history. It is a religious tract, or pamphlet, produced by the Drummond Tract Depot. This was set up by Peter Drummond (1799-1887) in 1848, and between then and its closure in 1981, an estimated 845 million tracts were published.

This tract, *Can Not and Will Not*, is a tiny publication measuring 4 x 2½ inches and is only eight pages long. Dating from about 1860, it was sold in bulk, with a hundred costing a shilling. Such pamphlets were in direct competition with the racy and salacious chapbooks. Like the chapbooks, they were read to destruction, and very few now survive. This tract was gifted to the Smith by poet, folksinger and bibliophile Adam McNaughtan.

The Drummond Tract Depot was based at the foot of King Street, and subsequently, in Dumbarton Road. Note that the tract is in the 'Snowdon Series'. Snowdon is the historic and poetic name for Stirling.

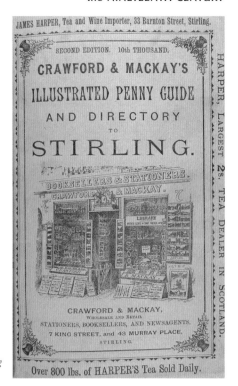

JAMES HARPER, Tea and Wine Importer, 33 Barnton Street, Stirling.

SECOND EDITION. 10th THOUSAND.

CRAWFORD & MACKAY'S

ILLUSTRATED PENNY GUIDE

AND DIRECTORY

TO

STIRLING.

BOOKSELLERS & STATIONERS.
CRAWFORD & MACKAY.

CRAWFORD & MACKAY,
WHOLESALE AND RETAIL
STATIONERS, BOOKSELLERS, AND NEWSAGENTS,
7 KING STREET, and 43 MURRAY PLACE,
STIRLING.

HARPER, LARGEST 2s. TEA DEALER IN SCOTLAND.

Over 800 lbs. of HARPER'S Tea Sold Daily.

Crawford & Mackay from a Stirling Penny Guide, 1883.

THIS RARE VIEW of Crawford & Mackay's news agency is from a Stirling Penny Guide, published by the company. It was gifted to the Smith collections by Janey Buchan, the former Glasgow MEP.

J.F. Crawford set up in business in 1837. Following his death, Eneas Mackay came to Stirling from Inverness in 1882, to help Mr Crawford's widow to continue the business. The windows are crammed with photographs, postcards and souvenirs for Stirling's tourists and the engraving shows that the company had a Royal Warrant above the door.

The address of the shop was No.7 King Street, which today is the shop of the British Heart Foundation. A trace of the stone balusters above the shop can be seen in the engraving.

Crawford & Mackay faced their main competitors, R.S. Shearer & Son, who were located opposite in the Golden Lion building at No.6 King Street. Thanks to the guides published by both Mackay and Shearer, Stirling's tourists were well served.

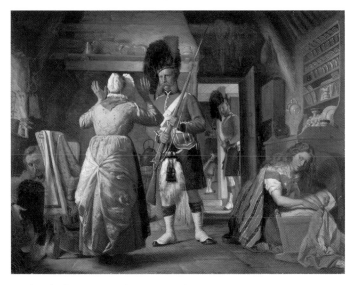

Searching for the Deserter. (Oil on canvas, 1868)

FROM THE EIGHTEENTH to the nineteenth centuries, Stirling had the character of a garrison town, with troops moving in and out, and either billeted in the castle or with local people according to the needs of the times. During the two world wars, even the Smith was used to accommodate troops.

Soldiers brought their own problems. According to the artist, this painting is of a real incident which took place in the Raploch. The indications that this is true are in the shape of the roof timbers of this cruck-framed house (Fisher's Row in Raploch was built in this way) and the pot of fuchsia at the window (Raploch was famed for its beautiful gardens). The 'deserter', hiding behind the chair, and the soldiers searching for him are wearing Black Watch tartan. The interior of the cottage is beautifully depicted. Deserting from the army carried severe penalties. Even those enrolled as volunteers in the Militia who failed to appear for training were regarded as deserters, and the penalty ranged from a 40s fine and two months' imprisonment to a £20 fine and six months' imprisonment. The penalties for those in the regular army were much more severe.

The artist Hugh Collins (1833-1896) favoured military subjects. Another of his paintings can be seen in the museum of the Argyll and Sutherland Highlanders in Stirling Castle.

Governess Cart, c. *1890.*

STIRLING, SITUATED AT the historical crossroads of Scotland, was once a significant carriage-building town, producing everything from baby carriages to rickshaws for export. The Governess Cart, gifted to Stirling by West Lothian Museums Service, was made at the works of William Kinross & Sons 1802-1966, which occupied the area which is now the Thistle Centre. They made horse-drawn carriages and, later, motor vehicles, and had a Royal Warrant from Queen Victoria.

Stirling's coach-building industry also included the works of George Thomson, McEwen's Pram Works (established 1861, the oldest in Scotland), and Alexander's in Raploch, where single-deck buses were built.

Although there are historical Stirling-built coaches throughout the world, they are becoming rarer and the Smith is grateful to the generosity of West Lothian Museums for enabling this part of Stirling's forgotten past to be celebrated.

The Argyll and Sutherland Highlanders 'Waiting to Mount Guard' at Stirling Castle, 1890. (Oil on canvas by William Kennedy)

THIS PAINTING BY the so-called 'Glasgow Boy' William Kennedy (1859-1918), shows the Argyll and Sutherland Highlanders 'Waiting to Mount Guard' on a hot summer's day, outside the Chapel Royal in Stirling Castle. The Argylls were – and as the Royal Regiment of Scotland, are – Stirling's resident regiment. They are distinguished by their green tartan and the double set of three 'tails' on the regimental sporrans.

From the nineteenth century up until 1964, the military occupied all of Stirling Castle, using it as a barracks and store. The military manoeuvres were part of Stirling's attractions to visiting tourists, and Kennedy was so fond of painting these scenes that he maintained a studio in the castle. He exhibited this picture at the Walker Art Gallery in Liverpool and in a Munich Secession exhibition.

Stirling was very much an artist's town in the nineteenth century. Kennedy spent some of the most creative years of his life here, 1886-1900. He met his future wife, the artist Lena Scott, when she was a student at Denovan Adam's school of animal art, at Craigmill, near Cambuskenneth. The area offered a picturesque setting for studies of rural life, opportunities for 'plein air' painting and cheap accommodation, all of which suited the artists.

six THE TWENTIETH CENTURY TO THE PRESENT DAY

Forthside, early 1900s. (Oil on canvas by John Holmes)

FORTHSIDE IS AN area of Stirling which few citizens really know, as it has been closed to general public access since 1886. At that time, because the army had outgrown the available storage area in Stirling and Edinburgh Castles, Forthside was acquired by the government for ordnance purposes.

Ordnance concerns the supply and provisioning of the army. At Forthside there were some sixty buildings, over a total area of 76 acres, between the River Forth and the railway station. A spur from the railway took supplies in and out, whilst a landing stage, built in 1889 brought goods by boat. In 1914, the River Forth was closed by order of the Admiralty to all except military craft serving the Ordnance Depot.

The Royal Army Ordnance Depot at Forthside was Scotland's main depot. It gave employment to about 150 civilians in time of peace, and it was very much like a town within a town. With the move to a modern depot in 1980, the late Major Peter Whitehead began to collect material relating to the history of the RAOC. Sensing that its history would be erased with the new development, he commissioned this painting of Forthside in the early 1900s, from John Holmes, for posterity.

The modern multi-million-pound Forthside waterfront development began in the late twentieth century. It has provided a multiplex 1,100-seat cinema (opened 2008), new residential and retail developments.

 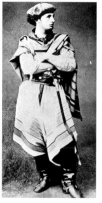

Robert Bontine Cunninghame Graham.

CUNNINGHAME GRAHAM (1852-1936) was one of the great men of Stirlingshire.

> Famous author, traveller and horseman. Patriotic Scot and Citizen of the World. Died in Argentina, interred at Inchmaholm. A Master of Life, a King among men.

These are the words on his memorial stone at Gartmore, the estate which he inherited, and which he tried to support through his work as a cattle rancher in South America.

Shown here are photographs of Graham in his gaucho's outfit at the age of eighteen, and in prison dress in later life when, as a radical MP, he was jailed for his political beliefs. He had the distinction of being the founder of two political parties during his lifetime – the Scottish Labour Party in 1888 and the National Party of Scotland in 1928.

Graham left his most treasured possessions, his riding boots and South American riding gear, to the Stirling Smith. The elaborate coffin plate produced by the Literary Society of Argentina was removed before he was buried. It too is in the Smith collections.

His legacy to the world was a treasury of short stories and novels, and the love of the lands of Menteith and all of Scotland expressed in them.

Photograph of Bannockburn Hospital, c. 1910.

BANNOCKBURN HOSPITAL OPENED in 1894 and was the first place to be built for the treatment of infectious diseases (enteric fever, scarlet fever and diphtheria) in Stirling. Prior to that, patients were taken to the Fever Hospital in Falkirk. The stylish building was designed by Stirling architects McLuckie and Walker and built with a £3,000 mortgage, repaid by the County Council over a thirty-year period.

In the first year it treated seventy-three patients who stayed forty-five days on average. Until 1920, the hospital was served by the horse-drawn ambulance or fever van, shown here with Matron Agnes Dempster and her nurses. The patients found the ambulance 'rough and jolting to a degree causing great discomfort'. It covered a very wide area and was slow, the double journey to Buchlyvie (for example) taking six and a half hours to cover just 34 miles, as the horses had to be fed and rested before the return journey.

By the time of the start of the National Health Service in 1948, infectious diseases were in decline, and the hospital began to treat older people admitted for long-stay care. A specialist purpose-built psychiatry assessment unit was added in 1994.

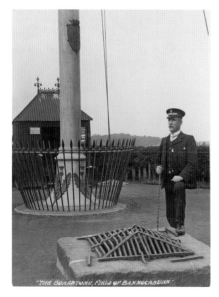

The Borestone, Bannockburn.
(Postcard, c. 1908)

OVER THE PAST few centuries, generations visited Bannockburn to touch the Borestone, where, according to tradition, King Robert the Bruce had planted his standard prior to the battle of Bannockburn, 23-24 June 1314.

In 1870, the large flagstaff was provided by the Oddfellows of Dumbarton and the Borestone itself was encased in iron grating to protect it from souvenir hunters. The corrugated tin hut in the photograph was probably put up at this time. The recent discovery of the Bannockburn Visitors Book, 1908-1923, in the offices of the *Stirling Observer*, reveals a lot about how the site was managed for visitors, together with the name of the guide, William Shaw, who in this photograph has the words 'Borestone Guide' inscribed on his cap. The hut carries the sign 'Official Guide Books and Pictorial Post Cards Sold Here'.

The hut was a shelter for both the Guide and the Visitors Book. Shaw welcomed visitors from all over the world and told them the story of the Borestone and Bannockburn. The hut was open for business, even on 31 December and 1-2 January when visitors signed the book.

The guide service was maintained during the First World War, and a humorous poem at the back of the Visitors Book suggests that the German Kaiser would be judged on the Borestone and made to paint the flagpole as a punishment.

The Chinese Coat, 1913. (Oil on canvas by John Munnoch (1879-1915))

THIS PAINTING AND its companion say much about the tragedy of the First World War (1914-1918) and its impact on the people of Stirling. As a work of art, it has been widely admired for its similarity to the work of Whistler. In 2008, it was selected by the *Daily Telegraph* as one of 'Fifty Great Paintings Across Britain'.

The artist John Munnoch lost his life in action during the First World War; his name is listed on Stirling's War Memorial. Although he was an accomplished artist, he exhibited only a few works before he volunteered. These included views of Stirling among other landscapes and portraits.

The subject in The Chinese Coat was Munnoch's fiancée, a Stirling girl whose name we do not know, when the painting was gifted by the artist family in 1936. In 2008, another portrait of Jessie McGregor (as we now know her to be) by Munnoch became available and was purchased for the Smith.

In retrospect, the portrait has a great sadness, echoing the loss of a whole generation of young men from every walk of life, who left wives and girlfriends to face the future alone.

Munnoch was an important Scottish artist. Born in Port Street, he attended Craigs School, the High School of Stirling and the Edinburgh College of Art. In 1912, he won the Carnegie Travelling Scholarship and Maclaine Watters Medal.

During the First World War, John Munnoch enlisted with the 5th Battalion of the Royal Scots. In his soldier's will of March 1915, he left his art books to his friend, the cabinet maker Henry T. Wyse, who had designed the furniture for the Stirling Homesteads housing development. His sweetheart, Jessie McGregor, was left some mementoes. He died three months later at Gallipoli in June.

Like many other women of her generation, Jessie McGregor never married.

David Buchan Morris. (Oil on canvas by Cowan Dobson (1893-1980))

D.B. MORRIS WAS one of the men who shaped Stirling in the early twentieth century. He was Town Clerk of the Royal Burgh of Stirling from, 1901-1934, and was given the Freedom of the Burgh, along with his colleague, Andrew H. Goudie, the Burgh Surveyor, on their retiral. They agreed that the main improvements to Stirling during their term of office included the surfacing of the roads with asphalt, cutting down the noise and dirt on the streets, the improvements to the water supply, and the introduction of municipal housing.

D.B. Morris was an accomplished historian. His book, *Robert Louis Stevenson and the Scottish Highlanders*, was a best-seller, and he published a large number of articles on Stirling history through the Stirling Natural History and Archaeological Society. A Son of the Rock (as all those born in Stirling are known), he frequented the Smith Institute (now the Stirling Smith Art Gallery and Museum) as a boy and was taught by Alexander Croall, the first curator. Morris later became a Smith Trustee, and was also a member of the Burgh School Board and a Governor of the Stirling Educational Trust.

This portrait was commissioned in 1927 by Stirling citizens in thanks for his twenty-five years of service as Town Clerk. Morris Terrace, off Baker Street, was named after him.

Photograph of William Harvey (1874-1936).

WILLIAM HARVEY WAS a writer, poet, historian, Burnsian, journalist and benefactor to the City of Stirling.

When Harvey was three months old, his father died. Due to financial constraints he was obliged to leave school at the age of eleven, to work to support his family. He was apprenticed to a hatter, and in 1889 he was engaged by William Kinross, Carriage Builders in Stirling.

From an early age he had a delight in writing, and won several competitions. As a young man, he wrote poetry and articles for the *Stirling Sentinel*. He published his first book at the age of twenty-one, and, by 1904, had seven works to his name. He moved to Dundee to work as a journalist, but never lost his love for his native Stirling. His experience of poverty led him to be involved in several Friendly Societies and in the Freemasons.

A meticulous researcher, he wrote widely on newspaper history and made a specialist collection of Scottish chapbooks, which were bequeathed to Stirling Library in 1936. A sum of money, retained in Trust until after the death of his son, came to the Stirling Smith in 2007.

The William Harvey Trust is operated to further research into the history of Stirling.

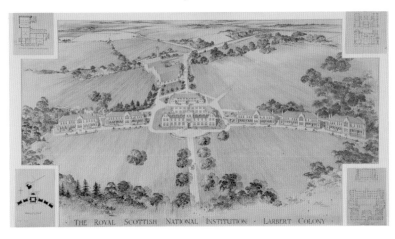

RSNI Larbert Colony. (Architect's drawing, 1928)

THE ROYAL SCOTTISH National Institution (RSNI) was the successor to the National Institution for the Imbeciles of Scotland, which was opened in 1863. Photographs of the first two pennies collected to fund the building are in the Smith's collection.

The drawing, in pen and ink by architect W.J. Gibson, was made prior to the building of the hospital in 1928-1935. The plan for those with mental health problems in this era was to isolate the patients from society in a grand institution in extensive grounds and to provide occupational therapy. The hospital was built for children with mental health problems from all over Scotland, but later admitted adults.

In 2006, the RSNI was demolished to make way for the new Forth Valley Royal Hospital, the largest NHS building to be built in Scotland to date. This replaced hospital services in Stirling, Falkirk and Clackmannan, with a phased opening between August 2010 and July 2011. The drawing was retrieved from the back of a suite of filing cabinets, prior to the demolition of the Institution.

Cambusbarron Quarry, 1932. (Oil on canvas by Henry Morley)

THIS WAS THE star painting in the 1932 Stirling Fine Art exhibition in the Smith Institute, when it was purchased for the permanent collections. It was painted by artist Henry Morley (1870-1937) who lived quite near, at Borestone Crescent.

This quarry was a limestone quarry and, from the eighteenth century, Cambusbarron was at the centre of lime production, with the quarries and associated lime kilns. Lime is important in the building industry and from it mortar, harling, plaster and lime washes are produced.

The quarry area is now popular with climbers and mountain bikers. Further quarrying which threatens to destroy the historic Gillies Hill is being vigorously opposed by the Save Gillies Hill Campaign.

Sir Walter Scott dressing table set from the 1920s.

SIR WALTER SCOTT has had a profound influence on Stirling. In 1810 his poem, The Lady of the Lake, was first published. It was set in the time of King James V, and although much of the action takes place in Loch Katrine and the Trossachs, the closing episodes are in Stirling and Stirling Castle.

The poem was a runaway success, and the nineteenth-century tourist industry was born with people flocking to Stirling and the Trossachs. Almost 200 years later, Stirling Literary Society commissioned a musical setting for the poem from Anne Lorne Gillies, and it is still a popular work.

This fine dressing table set of the 1920s shows Scott's home, Abbotsford, in the Scottish Borders.

St Mary's Wynd, 1930. (Woodcut by G. Elmslie Owen)

THIS CHARMING INTERPRETATION of St Mary's Wynd is in a series of twenty-one drawings of Stirling by G. Elmslie Owen; it was produced for the discerning tourist and published by Eneas Mackay of Stirling. The historical text in the book was supplied by David B. Morris, Town Clerk.

Although the scene is picturesque, the social conditions in St Mary's Wynd at this time were notoriously poor, with overcrowding and lack of both sanitation and sunlight. The street, at one time the main passageway from south to north through Stirling, was only 14ft wide at its narrowest point, and had many narrow closes on both sides.

The artist has used a woodcut effect technique to produce his images, a process as old as the art of printing itself. In 2007-8, the 500th anniversary of the introduction of printing to Scotland was celebrated in Stirling. In a lucid lecture, Observer Compositor (now journalist) John Miller explained how, until 1981, he was working with the same methods and technology as Guttenberg, who invented the printing process. The revolution of the computer screen changed the world of printing, and by 1989 the sub-editors had become the new typesetters.

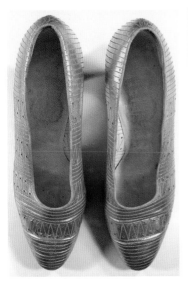

Gold shoes, 1936.

THE FIRST SHOPPING centre in Stirling came with the opening of the Thistle Centre in 1975. The centre doubled in size to become the Thistle Marches in 1999, and is currently known as The Thistles.

Before that, Stirling had a thriving retail trade based on local businesses, producing quality goods which were appreciated throughout Stirlingshire. One of the older businesses – still surviving today – is the department store of McAree (established 1878) in King Street, which also has branches in Edinburgh and Falkirk.

The gold shoes of 1936 were the property of Charlotte Elizabeth McAree, wife of proprietor John McAree. She purchased them from H. Ferguson's & Son, boot and shoemakers of Nos 16-18 Murray Place. In Ferguson's, customers sat upon a large central platform, and were served by an assistant at a lower level around it, so that they did not have to bend down to fit their shoes. Children could also have their foot size checked on the in-store X-ray machine.

From the impressed thistle mark inside the shoes, Ferguson's were working in partnership with Hector Maclaine of Bearsden & Watson of Falkirk. The shoes were presented to the Smith by Elizabeth Young, daughter of Charlotte and John McAree, who is still involved with the family business. The shoes represent high-quality, family-owned, Stirling-manufactured goods, many of which have disappeared in the globalisation process.

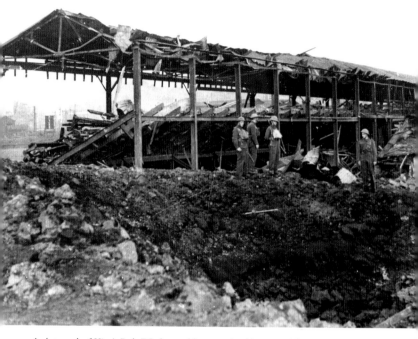

A photograph of King's Park FC, destroyed by enemy bombing on 20 July 1940.

DURING THE SECOND World War, only two bombs were dropped on Stirling; one in the country, the other on King's Park Football Club. The stand, terracing, press room, dressing room and offices were destroyed and an 18ft crater was left in the ground. The attack gave rise to the belief among boys in Stirling that Adolf Hitler was a supporter of the rival football club in nearby Falkirk.

The blast was enormous, and some nearby houses were demolished, while plate-glass windows in Stirling town centre were broken in the blast. There were a number of casualties, but fortunately no fatalities. A goldfish in one of the wrecked houses had its tail blown off, but was revived when some drops of brandy were administered.

After the war, the new Stirling Albion Football Club was created. It took its name from the Albion lorries which were used as temporary stands. In 2010, Stirling Albion made football history when the fans successfully acquired the ownership of the Club.

A photograph of two smoking soldiers, 1940.

TWO YOUNG MEN on active service, somewhere in Europe during the Second World War. They are enjoying a pint and a quiet smoke when off duty.

On the right is Billy Richardson. We do not know the name of his mate, but this is one of the photographs which Billy sent home to his mother at Keir Avenue, Raploch.

Three of Mrs Richardson's five sons were in service during the war; happily the other two were too young. Bert, Billy and John wrote regularly to their mother to keep in touch and cheer her up. Censorship and national security prevented them from revealing much detail, but the Richardsons were in the thick of it. Billy was involved in the relief of Bergen-Belsen and witnessed the full horror of the concentration camp there.

Since the introduction of the smoking ban in 2006, scenes like these have vanished with the cigarette smoke. At one time, the Player's Cigarette Factory in Springkerse was the biggest employer in Stirling, before its change of purpose into the Stirling Enterprise Park. It was Scottish Parliament First Minister Jack McConnell, so long associated with politics in Stirling, who introduced the ban. Many Stirling-based politicians have made their mark in national politics, and the smoking ban will be McConnell's legacy.

Christmas card etching by J.A. Girvan, 1941.

THIS IMAGE BY the artist James Alexander Girvan (1895-1951) shows the old Raploch Road, prior to its redevelopment with Council housing in the 1950s, with the picturesque backdrop of Stirling Castle.

Girvan was born in Glasgow and trained as a goldsmith and engraver, serving a five-year apprenticeship. After service during the First World War, he attended classes at Glasgow School of Art to improve his drawing skills. John G. Mathieson, a Stirling artist who lectured at the school, persuaded Girvan to move to Stirling, to assist with a gallery which he ran in Murray Place.

Mathieson, who lived at No. 16 Allan Park, arranged accommodation for Girvan at No. 1 Allan Park. For the next thirty years, Girvan undertook most of the quality engraving work in Stirling, including that for the regimental silver at the castle.

He was a skilled engraver who worked with etchers and sketchers in Stirling, including Sir D.Y. Cameron, Henry Morley and the architect Eric Bell. He commissioned Bell to design his new house at Whins of Milton. He also worked on photography projects with James Atterson (1891-1961), head teacher of the art department at the High School.

This card is one of a number of works donated by his son, the late W. Girvan, to the Stirling Smith.

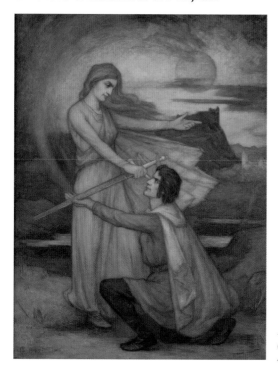

Bannockburn, 1943.
(Oil on canvas by
Stewart Carmichael)

THE VICTORY AT Bannockburn, 23-24 June 1314, has been celebrated in song, poetry, theatre, and art for almost 700 years. In the last decade, the re-enactments on the battlefield have become extremely popular.

This painting by artist Stewart Carmichael (1867-1950) dates from 1943. It is painted in the Symbolist style, and the artist was thinking primarily of the Second World War, which was raging at that time. It has one of the longest picture titles ever:

> Robert the Bruce receiving the Wallace sword from the Spirit of Scotland in the guise of the Lady of the Lake on the eve of Bannockburn, by Stirling Castle. Painted at a time when our ancient freedoms were under threat from Nazism and Fascism.

The purchase of the painting was made possible by the generosity of the Friends of the Smith, after local art dealer Neil McRae discovered it in a London auction.

Stirling Victory Day Programme,
8 June 1946.

THE VICTORY DAY programme cover was designed by James Atterson (1898-1961), art master of the High School of Stirling.

During the month of June, thoughts in Stirling turn to Bannockburn, and Bruce's great victory over the English in 1314. In his cover design, James Atterson has associated the victory at Bannockburn with the victory of the Allies in the Second World War, as many did. The medieval soldier is standing on the swastika as the rising-sun flags of the vanquished nations and the Wolf of Stirling, the heraldic beast of the city, continue to sit on guard at the foot of the castle.

Atterson was an accomplished artist, who served both the school and the local community well. The High School lost many pupils in both world wars, and, in 1949, Atterson designed their commemorative stained glass window and Book of Remembrance. In 1954, he designed and painted all the scenery for the Battle of Balaklava Centenary Show in the Albert Halls.

Tragically, he lost his life in a motoring accident in 1961.

The Stirling Guide of 1950.

STIRLING HAS BEEN a tourist town for over two centuries. The Stirling Guide of 1950 is one of thirty-four historic guides gifted to the Stirling Smith in 2007 by Rudi Wolter, following his retirement from service in the Planning Department. The annual guides paint a good picture of Stirling's attractions.

Although Stirling as a publishing town printed its guidebooks locally at the start of the century, the official guidebook was contracted out to a London printer by 1950.

The group of civic buildings in Corn Exchange Road comprise one of the most attractive cityscapes in Scotland. The Burns Monument on the left was unveiled in 1914, just as war broke out. The Municipal Buildings, designed by the Glasgow architect John Gaff Gillespie (1870-1926) in 1908, were not completed until after the war in 1918. To the right is the tower of the Athenaeum, built in 1817. It served as the burgh offices from 1875, until the completion of the Municipal Buildings. To the right again is the War Memorial, built in 1922.

The other public building which complements this attractive group is Stirling Central Library, which opened in 1904. Corn Exchange Road was created to join the old upper town from Spittal Street to Dumbarton Road at this time.

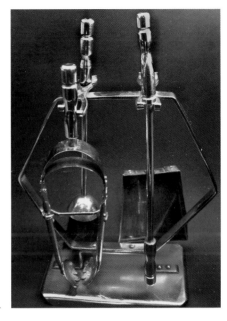

Companion Set, 1950.

'HAVE NOTHING IN your house which is neither useful nor beautiful.'
This advice by the designer William Morris is also valid for museum
collections, and Smith curators often use it when offered objects for
the collection.

The Companion Set, made in the High School of Stirling by a
pupil for his Higher Leaving Certificate in Technical Drawing and
Metalwork, is both useful and beautiful. In the days of coal fires, the
fireside companion set, with poker, brush, shovel and tongs, was a
necessity in every household. The High School pupils were challenged
to design and construct one as part of the examination process.
This involved drawing a template, then cutting, folding, brazing and
soldering the metal pieces, as well as cutting the screw threads on the
steel rods, to fix the handles. The piece was then chromed locally.

This Companion Set only fell out of use with the disappearance of
coal, and has now been retired to the Smith.

The Black Boy. (Stirling Observer *magazine*)

SOMETIMES, IMPORTANT LOCAL landmarks are overshadowed by later developments. This is certainly the case with the Black Boy, a cast iron fountain made in James Neilson's Glasgow foundry and brought to Stirling in 1854. Over a century later, it starred as a focal point on the Christmas number of the *Stirling Observer*, 1956, but today Stirling's Christmas lighting is focussed on a more temporary structure.

The fountain was possibly made for the 1851 Crystal Palace exhibition, and relocated in Stirling on an open piece of ground known as the 'Gallows Mailing' outside the old burgh gates. The area had a gibbet for public hangings which was removed in 1785. Thereafter, it became 'the camping ground for tinkers and various other undesirables' and, in an effort to move them on, the Allan Park residents secured the fountain and landscaped the ground.

A newspaper report of 1949 claimed that the residents failed to pay the costs of the fountain but managed to keep it. However, they paid for 'a serious major operation' on the Boy, the surgeon being Sandy Grove, of Messrs Davie & Sons, Ironfounders, Orchard Place. With a hacksaw and a soldering bolt, he made the Black Boy respectable for public viewing at a cost of £2.

The fountain was restored in 1997 by Dorothea Restoration Ltd, and in the summer, the water still flows.

The Stirlingshire Yorkshire Society.
(Club Memorabilia, 1960s)

THE STIRLINGSHIRE YORKSHIRE Society was founded by Joan Adam of St Hilda's Hotel (now the Terraces Hotel, Melville Terrace) in 1964. It was formed to bring together all people of Yorkshire extraction living in Stirlingshire, and to maintain an interest in Yorkshire traditions and characteristics. As membership had declined, members Alice Hainsworth and Betty Roy (pictured) decided in 2004 to deposit the insignia in the Stirling Smith.

The insignia includes the President's chain, made of silver with white enamel Yorkshire Rose links, commissioned from York jeweller A.E. Hopper in the 1960s. There is also a fine linen table cloth, the centre of which was sewn by the students of Hull Art College. The cloth is embroidered with the names of all the members of the Society in the 1960s. The signatures were sponsored at *2s 6d* each to raise the necessary funds for the chain of office.

Today there are many groups of people from different parts of the world living in Stirling, but it is good to think that there was a significant Yorkshire community who were determined to celebrate and preserve their traditions here. The people of York have some of the best museums in Britain, and their respect for their heritage is characterised by this valuable donation to the Stirling Smith.

Stirling Valentine Story, produced by the Drummond Tract Depot in the 1950s.

THIS SIXTY-FOUR-PAGE ROMANCE novel was one of hundreds produced in Stirling in the twentieth century by the Drummond Tract Depot, based in Dumbarton Road. *Ward 7* dates to the early 1950s and was a gift to the Smith by folk singer and book seller Adam McNaughtan.

The main aim of the Drummond Tract Depot (also known as the Stirling Tract Enterprise) was the sustenance of a Christian society. All of their publications emphasised the importance of Bible knowledge and study. The nurse in this story prays for the conversion of the doctor to Christianity as the Bible says 'Be ye not unequally yoked together with unbelievers'. The doctor is converted by a Scottish seaside missionary, and romance ensues. By the end of the story, the nurse and doctor have embraced once and agreed to a two-year engagement. Other characters have been saved from drink and re-united with their families.

The author was E.K. Richards and the charming illustrations were by F.T. Holmes. The printing was undertaken by *Stirling Observer* printers Jamieson and Munro. Although such books were produced in their thousands, they were read to destruction, and few survive today.

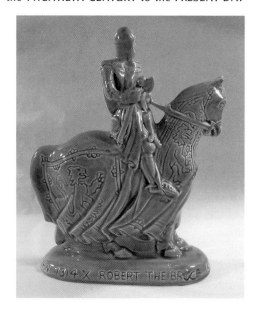

Stirling souvenir.

OVER THE LAST 200 years, tourists visiting Stirling have complained from time to time that there have been no locally-made or even Scottish products available in the shops. When the market was flooded with cheap German pottery, the custodians of the Wallace Monument received letters of complaint from patriotic visitors who had no understanding of market forces!

This pottery model of Charles d'Orville Pilkington Jackson's sculpture of King Robert the Bruce at Bannockburn was produced by the West Highland Pottery Co., Dunoon, for sale at the National Trust visitor centre in 1964. The statue was unveiled by Her Majesty the Queen on the 650th anniversary of the Battle of Bannockburn, as it was important to have Scottish-made souvenirs for visitors.

A Stirling Smith Gallery Guide, who worked at Bannockburn as a student in 1964, recalls:

> The postcards and souvenirs were fairly sparse in the first few years. The Dunoon Pottery model of the statue was produced in green or brown and cost 30 shillings, too expensive for a poor student to buy. We were delighted when the copper coasters from Pentland Coppercraft arrived, and I bought the one I have donated to the Smith as a present for my mother!

Corbiewood racetrack, 1979. (Oil on canvas by D. Parry)

THIS PICTURE WAS commissioned in 1979 for the walls of the Jockey Club Public Bar, in the Bannockburn Hotel, by landlord Tom Coll. The Jockey Club was the favoured meeting place of the jockeys and horse owners involved in harness racing at the Corbiewood trotting track.

In the late 1970s there were proposals to upgrade and improve the track, but before it was lost to redevelopment, Tom Coll wanted a record of the old track. Artist D. Parry, who worked for the *Sunday Post* in Dundee, visited Stirling several times to take sketches and photographs, and get the detail right. He took only one artistic liberty. Maw Broon from 'The Broons' cartoon series is in the picture, bottom left.

The finished work proved to be too large for the wall of the Jockey Club. The improvements to the track did not go ahead, and the track has remained much the same to this day. When Tom Coll retired in 2007, he gifted the painting to the Smith.

Harness racing or Trotting come to Stirling with the Irish community, who settled in the Raploch area. After the Raploch Quarry was filled in during the Second World War, it became the Quarry Park, and the harness racing was based there. When the site was chosen for Stirling Fire Station in 1965, the racetrack was moved to Corbiewood.

Sporting pictures of Stirling are quite rare. The Corbiewood painting is a welcome addition to the collection, in the care of the Smith Trustees, on behalf of the people of Stirling.

Castle Hill Mindins, 2003. (Oil on canvas by Sheena Wilkie)

PAINTED IN 2003, the subject of this painting is the artist's childhood in the 1950s. The scene is set in one of the streets in the old town, just below the castle. The totally traffic-free street is the children's playground and their world is dominated by the historic castle above. The two children in the foreground are placing an injured bird into a box; others are drawing with chalk on the pavement.

Sheena Wilkie left Stirling at the age of twenty-two and then lived in Sussex for nearly thirty years. She came to realise that the history and landscape of Stirling had underpinned her work as an artist, and so she returned to capture these childhood impressions in paint. She is still part of the vibrant contemporary art community in Stirlingshire today.

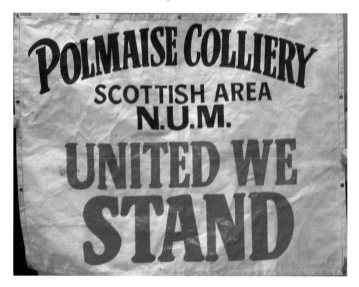

Polmaise Colliery banner, 1984.

POLMAISE PIT IN the east Stirlingshire village of Fallin was one of the most progressive, productive collieries in Scotland. The pit was sunk in 1904, and over 1,000 men worked there. By the 1980s, mechanisation saw a levelling of the work force down to 700.

In December 1983, Polmaise was threatened with closure and in a political move, the miners were locked out. The threat against Polmaise and four other mines precipitated the Miners' Strike of 1984-5. The Polmaise miners were out on strike three weeks before, and back to work a week after the strike of 1984-5 finished – the longest ever strike in the Scottish coalfield.

The Polmaise miners led off most of the great marches of 1984-5 behind this specially-made PVC banner, which featured constantly in the news reports of the day; the banner subsequently became an iconic image of the strike. It was believed to be destroyed after the closure of the pit in June 1987, but following an appeal in 2009, it was secured for the Stirling Smith and restored by painter Kevin Meek, with specialist PVC banner paint sourced by D-signs of Stirling.

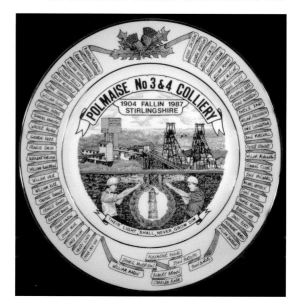

*A Polmaise
Colliery plate.*

THE VILLAGE OF Fallin owes its existence to Polmaise Colliery, and a small open-air museum is now on the site of the pit entrance. After the closure of Polmaise Colliery in 1987, this plate was produced to commemorate its loss, and the loss of the lives of fifty-five men who died there, through accidents at work. The price of coal has always been high.

The opening of deep mines in Stirlingshire in the early years of the twentieth century changed the social and political mix of Stirling. Miners came from smaller collieries in Lanarkshire and from Ireland to work the new deep mines of Cowie (opened 1896), Milhall (1904) and Fallin (1905).

Their struggle for adequate housing, safety at work and a living wage introduced the politics of social justice to a traditionally conservative area. The Stirlingshire mines delivered record productivity and output until the enforced closures.

This plate is part of a collection of mining memorabilia presented to the Stirling Smith by retired colliery workers, engineers William McKinlay and electrician Raymond Frew.

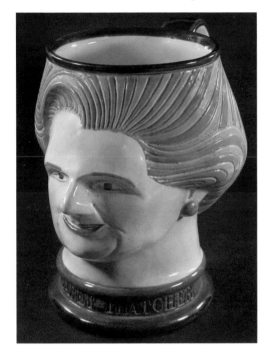

A ceramic mug depicting Margaret Thatcher at the time of the invasion of the Falklands in April 1982.

THIS MARGARET THATCHER mug is no.17 in a limited edition of fifty, made by James Campbell of Cawdor, showing Mrs Thatcher at the time of the invasion of the Falklands in April 1982. It is a sympathetic portrait, unlike the Spitting Image dog toy, teapot, key ring and 'milk snatcher' mugs of the same date.

Mrs Thatcher was the British Prime Minister, 1979-1990. One of her most important political disciples in Scotland was Michael Forsyth, Member of Parliament for Stirling 1983-1997 and Secretary of State for Scotland, 1995-1997. Much national attention was focussed on Stirling during his time, and, among other things, he launched the Stirling Initiative and organised the return of the Stone of Destiny to Scotland in 1996.

He was defeated by Anne McGuire, Stirling's first ever female Member of Parliament in the General Election of 1997. Some believe that the increase in Anne McGuire's majority in 2010 was due to the memory of Mrs Thatcher's time in office.

James Campbell is now an internationally known ceramic artist, with collections in museums in Japan, Australia and Scotland.

Gilbert & Sullivan gate screen, 1988.
(Stainless steel by Robert Hutchison)

THE HISTORY OF metalworking is important in the Stirling area. The connection began with the opening of the Carron Iron Works in 1759. There were many small foundries operating in and around Stirling well into the twentieth century. However, only one now remains.

The gate screen comes from the older blacksmithing tradition, also very strong in Stirlingshire because it is in the centre of a large farming area. The artist has worked in traditional blacksmithing as well as being an artist blacksmith.

These gates were designed to be sited in Embankment Gardens, London to commemorate the centenary of the Savoy Hotel and its links with Gilbert & Sullivan and the D'Oyly Carte company. The project started in 1988 and was a collaboration between British Steel officials, who wanted the work done in stainless steel and Sir Hugh Wontner, owner of the Savoy Hotel. Robert Hutchinson, artist blacksmith, was chosen as the manufacturer. The late Queen Mother was interested in the project, and it was planned to ask her to open the gates. Unsurprisingly, due to the notoriety of the scheme there was much press interest during the design and construction process.

However, as the Savoy Hotel was subject to a take-over bid, focus on the gates was distracted and the project was seriously set back when Sir Hugh Wontner died in 1992. The Savoy was eventually taken over and the Savoy theatre (built 1881) burned soon afterwards. British Steel had ceased trading in 1999, and the gates never left Stirling. Luckily the people of Stirling also have a keen appreciation of the works of Gilbert & Sullivan.

The gates, which weigh 800cwt, are designed and manufactured to withstand all that weather and vandalism can throw at them, and to be maintenance-free. They are installed as a permanent screen in the grounds of the Smith and the subjects featured are The Mikado, The Pirates of Penzance and HMS *Pinafore*.

135

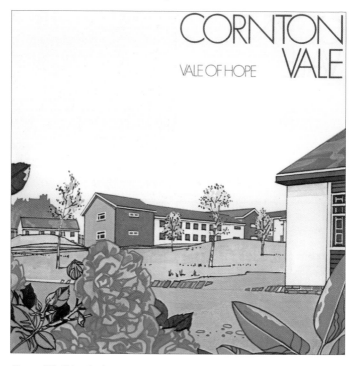

Cornton Vale Prison brochure, 1975.

CORNTON VALE WAS built in Stirling as the main women's prison for Scotland in 1975. Stirling was chosen as the venue for its central location and the ease of access from all over Scotland. It was a bright, modern alternative to the grim facilities of Greenock Women's Prison, which it replaced. The first Governor was Lady Martha Bruce, 1975-1983. In recent years, prison authorities have struggled to cope with the overcrowding which has precipitated an increase in alcoholism and drug abuse.

The site dates back to the early 1900s, when Cornton Vale House Health Spa was acquired by the Church of Scotland as a farm colony for inadequate and alcoholic men in 1908. In 1946, it became a Borstal Institution for young men. Then, in 1971, the Borstal Boys were given the task of building the new prison.

Cornton Vale is very much part of the rich tapestry of Stirling's history, even in literal terms, because the Fine Cell Work members of the Stirling Embroiderers' Guild teach needlework there.

Central Regional Council, 1975-1996.
(Stained glass panel by Emma Shipton)

FOR OVER TWENTY years, the Stirling, Clackmannan and Falkirk areas worked together under the administrative umbrella of Central Regional Council. Their contribution to the Glasgow Garden Festival in 1988 had a railway theme, the ease of communication being one of the defining features of Central Scotland. This stained glass window was commissioned as part of the exhibit, making a strong visual statement on the region. It was designed by Alexander Parker and executed by Emma Shipton, a stained glass graduate from Edinburgh College of Art, who for some years ran Aurora Glass of Alloa.

Many of the iconic images of Central Scotland have been incorporated into this window – Stirling Castle, the Wallace Monument, the Forth & Clyde Canal, the textile mills of the Hillfoots and the coal mines of eastern Stirlingshire. The tower of the Gestetner Factory – now Ricoh, at Cambuskenneth – also features.

After the Garden Festival, this panel was exhibited at the entrance to the Council's main chamber in Viewforth, serving as an artistic corporate identity statement, and featuring on CRC Christmas cards for several years. In 1996, it was gifted to the Stirling Smith.

'Breaking the Habit' by George Wyllie. The sculpture commemorates the Dunblane Tragedy, of 13 March 1996.

ST ANDREW IS the patron saint of Scotland, and his day on 30 November was declared as a public holiday by the Scottish Parliament in 2007.

There are various St Andrew's crosses, or saltires, in the Smith collections, but this, by the sculptor George Wyllie, is the largest and heaviest of them, and the cross is blood-red. Titled 'Breaking the Habit', it consists of a shotgun in presentation case, neatly sawn into four pieces. It was made by the sculptor to commemorate the Dunblane Massacre of 13 March 1996, when sixteen primary school children and their teacher, Gwen Mayor, were slaughtered by a gunman.

The sorrow, grief and anger have left an indelible mark on the community. The people of Dunblane and Stirling were determined to change the firearms laws – breaking the habit – and their Snowdrop Campaign succeeded in doing this, when hand guns were banned.

Snowdrops are the only flowers to be seen in the area in March.

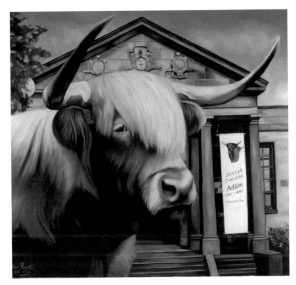

Hamish McKye.
(Oil on canvas by
Greer Ralston)

HAMISH, THE HIGHLAND bullock who joined the staff of the
Stirling Smith as External Relations Officer in 1996, was a legend in
his own lunchtime. The occasion was the centenary exhibition of the
artist Joseph Denovan Adam (1841–1896).

Adam ran a school for animal art at Craigmill, near Cambuskenneth,
and kept a fold of Highland cattle for his students to paint. During
1996, the Smith kept some farm animals for the same purpose.

The Bovine Spongiform Encephalitis (BSE) crisis hit the farming
industry when the exhibition opened. Stirling stopped selling cattle in
the auction marts. Hamish faced the prospect of slaughter, along with
every other cattle beast aged three years and over. The 'Save Hamish'
campaign succeeded and Hamish, now a very mature beast, works in
other fields, for Scottish tourism at Kilmahog, to the north of Stirling.
The cattle trade recovered, and both the headquarters of the Scottish
livestock marts, United Auctions, and the Highland Cattle Society,
relocated to Stirling in 2009.

Artist Greer Ralston still works in the tradition of the Craigmill
School of Art, which drew its inspiration from the countryside.
Many of the so-called Glasgow Boys were attracted to Craigmill and
Cambuskenneth to paint in the period 1880–1920. Greer is a Glasgow
School of Art graduate who lives and works in Stirling.

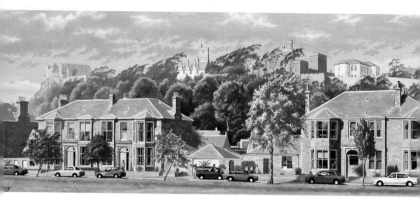

Stirling from Victoria Square, 1998. (Oil on canvas by A.C. Berry)

THE UNIVERSITY OF Stirling came into being in 1967, and the city has benefited from the intellectual talent and diversity which the staff and students have brought.

Anthony C. Berry is a retired malacologist (a biological scientist who studies molluscs) who worked at the Universities of Malaya and Stirling and took up painting in his retirement. The Stirling cityscape is his preferred subject.

The view is similar to that chosen by Johannes Vosterman in the 1660s, showing the wonderful skyline of the upper town – the castle, Cowane's Hospital, Church of the Holy Rude, Old Town Jail and Erskine Marykirk – but with the Victorian King's Park in the foreground.

Today, we do not think of Kings Park in terms of being a visitor destination, but when the castle housed a military garrison and was there for national security, visitors to Stirling were directed to Kings Park for rest and recreation. The tennis courts, putting green and band stand, and the stunning views of the town, were as much appreciated by tourists as by locals.

New Labour in Stirling. (Ink and wash on paper by Frank Boyle)

'IF RABBIE BURNS tried to stand as a Labour MSP today' is how cartoonist Frank Boyle characterised the hubris surrounding the selection of Labour candidates for the new Scottish Parliament.

The campaign for a Scottish Parliament lasted most of the twentieth century. Some of the politicians who campaigned the hardest, such as Dennis Canavan, MP for West Stirlingshire 1974–1983 and Falkirk West 1983-2000, suddenly found that their faces did not fit. After Canavan failed the selection panel chaired by the leader of the Labour Party in Scotland, Donald Dewar, he learned that in Dewar's opinion, he was 'simply not good enough'. The electorate disagreed. Canavan stood as an independent candidate and was returned with a hugely increased majority: the highest majority of any member of the Scottish Parliament in the 1999 elections.

Amongst other things, Dennis Canavan successfully promoted the St Andrew's Day Public Holiday (Scotland) Act of 2007 and introduced amendments to the Land Reform (Scotland) Bill, extending public right of access to country estates.

Before entering politics, Dennis Canavan was head teacher of mathematics at St Modan's High School, Stirling, where cartoonist Frank Boyle was later a pupil. Boyle was voted Scottish Cartoonist of the Year in 2003 and 2006. Although Boyle works for the *Edinburgh Evening News*, he maintains a strong connection with his home town of Stirling, and an annual Frank Boyle award for cartooning is made by St Modans.

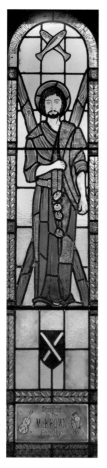

Stained glass window representing St Andrew's Day Bank Holiday. (St Modan's High School)

THE ST ANDREW'S Day Bank Holiday (Scotland) Act 2007 is a near-contemporary of the stained glass window of the saint, commissioned for the new St Modan's High School in 2008; both were created in Stirling.

St Andrew, brother of Peter, was the first disciple whom Christ called to follow Him. Andrew was crucified by the Roman governor Ageas, on a Saltire cross, in Patrae, Greece on 30 November AD 60. St Andrew is a significant saint in both the Greek and Russian Orthodox Churches, which celebrate him as the 'Protocletus' or first called among the disciples.

Since the eighth century, he has also been known as the Apostle of the Scots, following the victory of King Angus McFergus (AD 731-761) against the invading army of Athelstan. A saltire cross appeared in the sky before the battle, as a token of the saint's support of the Scots.

After the Catholic faith was swept away by the Scottish Reformation of 1560, the honouring of the saints was forbidden. In the nineteenth and twentieth centuries, St Andrew became a focus for Scots living abroad, with societies founded in his name. In the late twentieth century, with the pressure for a Scottish Parliament came the demand that St Andrew's Day should be celebrated as a public holiday.

A Bill was presented in the Scottish Parliament by Stirling resident, Dennis Canavan MSP. This became the St Andrew's Day Bank Holiday (Scotland) Act of 2007.

St Modan's High School is one of several new high schools built under the private finance initiative (PFI) in Stirling. The St Andrew window is one of three commissioned for the school chapel and made by Bryan Hutchinson, stained glass artist.

Judy Murray. (Charcoal on paper by Nicola Carberry, 2008)

THE STIRLING SMITH has a fine collection of historical portraits, but it is important to add to the collection so that the present generation is represented.

In 2008, the Stirling Smith was chosen as the only Scottish venue for the exhibition of the drawings of Leonardo da Vinci from the Royal Collections Trust, Windsor. During the National Campaign for Drawing's Big Draw month, a number of artists were engaged to draw Stirling people of the present, to add some twenty-first-century faces to the Stirling Smith collection.

Artist Nicola Carberry gave a public demonstration of how she draws portraits with this portrait in charcoal of Judy Murray. Judy is from Dunblane, and is internationally known as a tennis coach and mother of tennis stars Andy and Jamie Murray. She has elevated coaching to a whole new level and she has proposed to set up an elite tennis academy based in Bridge of Allan, to nurture future tennis stars. She has been involved in the creation of new facilities elsewhere in Stirlingshire, and was the natural choice to open The Peak, Stirling's new state-of-the-art sports village in 2009.

Excellence in sport and physical health is part of the planned future of Stirling, since the University of Stirling was designated as Scotland's University for Sporting Excellence. The aim of the university is to bring together an unrivalled critical mass of knowledge, sports facilities, sports agencies, governing bodies and leading academic researchers on a single site, characterised by excellence.

Stirling has had a reputation for good health and longevity since the eighteenth century. It is one of the most favoured cities in Scotland in which to live, a position which Stirling Council strives to maintain.

This is a good place to finish this history of Stirling, but suggestions of additions to the Stirling Smith collections for future editions are most welcome.

Other titles published by The History Press

Haunted Stirling

DAVID KINNAIRD

This volume contains a plethora of spooky tales from around Stirling, including a whole chapter on the mysterious goings-on at Stirling Castle, where cleaners in the King's Old Building claim to have heard footsteps coming from the third floor – which hasn't existed since a fire in the nineteenth-century – and a 1930s' photograph purporting to capture the shadow of a phantom guardsman.

978 0 7524 5844 1

The Guide to Mysterious Aberdeenshire

GEOFF HOLDER

This fascinating guide offers an invaluable insight into the mysterious Scottish county of Aberdeenshire, detailing the strange and uncanny in an accessible and enchanting way. Every historic site and ancient monument is explored, along with the many hidden treasures to be found in the area, with everything from beautiful ruins, stone circles and eerie sculptures to the sinister-looking wickerman covered.

978 0 7524 4988 3

A Grim Almanac of Edinburgh & the Lothians

ALAN SHARP

Beneath the surface respectability of Edinburgh lies a warren of filth-ridden alleys and stairs where thieves, murderers and ghouls of every description planned and carried out their foul deeds. Including Major Weir, the devil-worshipping black magician; Jessie King, the notorious Stockbridge baby farmer; and Mr Burke and Mr Hare, who plied their swift trade in corpses for the dissection table of Dr Knox.

978 0 7509 5105 0

Angus In Old Photographs

FIONA C. SCHARLAU

This fascinating selection of over 200 historic photographs, drawn from the collection held at Angus Archives, features herring packers, seaside entertainers, tinkers, provosts, factory workers, raspberry pickers and fishwives, among others. It also provides a nostalgic insight into the changing history of the area over the last century. Each image is accompanied by a detailed caption, bringing the past to life.

978 0 7509 5089 3

Visit our website and discover thousands of other History Press books.
www.thehistorypress.co.uk